History Is Now:
7 Artists Take On Britain

SOUTHBANK
CENTRE
**HAYWARD
PUBLISHING**

Foreword

History Is Now: 7 Artists Take On Britain offers a highly innovative approach to exploring the cultural history of the United Kingdom over the past 70 years. Hayward Curator Dr Cliff Lauson invited seven artists – John Akomfrah, Simon Fujiwara, Roger Hiorns, Hannah Starkey, Richard Wentworth, and Jane and Louise Wilson – to curate distinct sections of the exhibition, each of which brings together particular sets of thematic ideas and objects in order to re-examine different slices of the nation's social and cultural life during this period. The artists have selected artworks from both public and private collections as well as informal collections, and objects such as maps, newspapers, films, photographs, and scientific and military artefacts. Their varied and highly original curatorial 'takes' on Britain provide fresh perspectives and illuminate key episodes in the nation's journey from the post-war period to the present. At the same time they invite us to reflect on how we remember and reconsider the past.

This exhibition is part of Southbank Centre's *Changing Britain 1945–2015* festival, which is designed to provide a multi-faceted and dynamic investigation of our post-war history as a prelude to the 2015 May general election. Like the wider festival, *History Is Now* aims to provoke reflection and debate over the journey the nation has taken in recent decades and how this can shape our understanding of the present and future directions that we collectively choose to pursue. The decision to invite a range of artists from different generations as co-curators of the exhibition reflects the Hayward Gallery's long-standing commitment to the notion of the artist as a thinker attuned to important changes in society who is also able to reflect on those changes in ways that eloquently address the complexity of our histories and lived experience. By making unexpected and provocative connections between objects and ideas, the artist-curators of *History Is Now* invite us to reconsider familiar notions of our past, and thus to change our view of the world that we live in today.

The realisation of this ambitious and challenging exhibition has drawn on the contributions and assistance of many individuals and institutions.

For their generous support of *History Is Now*, I wish to thank the Wellcome Trust, The Henry Moore Foundation and the BFI, as well as Tony Elliott, Lisson Gallery, Maureen Paley, London, and Tanya Bonakdar Gallery, New York. We are also very grateful to the many lenders to the exhibition, including individual collectors, museums, galleries, foundations, archives and libraries, and the participating artists themselves (a full list of lenders appears on p. 192). Almost 40 per cent of the 250 objects and artworks in the show have been borrowed from the Arts Council Collection, and our thanks go to Jill Constantine, Head of the Collection, and her highly skilled team for making so many works available to this exhibition. In addition, a very special thanks goes to the RAF Air Defence Radar Museum for allowing us to borrow a decommissioned Bristol Bloodhound missile.

Cliff Lauson has brought this project to fruition with great skill and intelligence, managing its daunting logistics while engaging his artist co-curators in continual and creative conversation. Assistant Curator Eimear Martin, along with Curatorial Assistants Debra Lennard and Charlotte Baker, rose to the occasion and did an exemplary job of organising the varied challenges of bringing this show together. Andreas Lechthaler brought his customary ingenuity to bear on the exhibition design. Hayward Operations Manager Thomas Malcherczyk and Senior Technician Gareth Hughes ably oversaw the installation, with Hayward Registrar Imogen Winter supervising the transport and care of the many objects

and artworks involved. As always, Hayward General Manager Sarah O'Reilly played an indispensable role by expertly providing insight and assistance in numerous ways.

Our gratitude also goes to the authors of the original and illuminating texts in this catalogue: Sheila Dillon, Adrian Forty, Daniel Fujiwara, Charlotte Higgins, Jackie Kay and David Alan Mellor, as well as Cliff Lauson. Hayward Interpretation Manager Lucy Biddle also contributed key texts to the catalogue, as well as doing a superb job of developing interpretative materials for the exhibition. Hayward Art Publisher Ben Fergusson and his team managed all aspects of this publication with alacrity and thoughtfulness; we are also grateful to the design studio Julia for their elegant design of this book. And a special thanks goes to James Runcie, Head of Literature and the Spoken Word at Southbank Centre, for suggesting the show's title, which is borrowed from a line in T.S. Eliot's 'Little Gidding', a poem written during one of the darkest years of World War II.

As always, I am very grateful for the enthusiastic support of Alan Bishop, Southbank Centre Chief Executive, and Jude Kelly, Artistic Director, as well as Southbank Centre's Board of Governors and Arts Council England. Finally, our most profound thanks go to the artist co-curators of *History Is Now*, who have infused this project with their remarkable thinking, insight and imagination.

Ralph Rugoff
Director, Hayward Gallery

The Storm We Call Progress

'The themes and episodes chosen by the seven artists
fold over and slide alongside one another,
bridging conversations and drawing out themes
across time and place.'

In December 1942, while Allied and Axis forces fought on land and sea, and in the air, chair of the Committee on Social Insurance and Allied Services, Sir William Beveridge, published his findings and recommendations from a year's research on British life and society. Commonly known as the Beveridge Report, it described a series of economic and social reforms, the blueprint of what would become the post-war welfare state.[1] This standard-issue government policy document sold a remarkable half a million copies; after three years of war, the people of Britain were desperate for improvements. Small steps were made in the years following the report's publication, but by and large they would have to wait until peacetime, when the newly elected Labour government attempted to address what Beveridge had identified as the 'five giant evils' of society: squalor, ignorance, want, idleness and disease. In the wake of war, Prime Minister Clement Attlee was faced with the enormous tasks of not only rebuilding Britain, but also trying to imagine what its future could be.

Fast forward to the present day, and as we look back upon the rhizome of people, places and events, it becomes clear that no ideal future could have been realised, nor could we easily claim that those five evils have been vanquished. The fabric of history seems impossibly dense and complex, propelled forward by what German philosopher Walter Benjamin described as 'the storm' that 'we call progress'.[2] On the eve of the 2015 general election, we mark 70 years since the end of the Second World War – approximately a lifetime of British history. In order to explore and better understand this period, seven artists of different generations and backgrounds have been invited to look upon it with curious eyes, and choose artworks and objects that prompt us to reconsider the past in new ways. Each has selected episodes, themes and ideas that intrigue him or her, in a way filtering our collective histories through their own personal perspectives. The resulting sections are less re-tracings of straightforward textbook narratives, but more leaps across time and space, with the artists' visual intelligences forming the connective tissue between material culture and immaterial history. If, as William Coldstream wrote, 'an artist is a specialist in looking and seeing', then John Akomfrah, Simon Fujiwara, Roger Hiorns, Hannah Starkey, Richard Wentworth, and Jane and Louise Wilson are the focusing lenses through which we might reconsider and re-evaluate our recent past.[3]

Inviting seven artists to curate *History Is Now* places it in a long line of artist-curated exhibitions, extending back to at least nineteenth-century Paris when Gustave Courbet, soon followed by the Impressionists, refused the institutional authority of the Beaux-Arts Salon, and instead staged their own exhibitions.[4] This rebellious spirit, and freedom to make the exhibition itself a kind of medium – defined in contradistinction to the formal institutions of art, and conveying an overarching artistic intention – carries forward to the present day and to the current exhibition. In addition, the rise of 'installation art' as a genre since the 1960s has further blurred the lines between the craft of exhibition-making and the creation of a large-scale artwork in its own right. For *History Is Now*, the guest curators have exercised the greatest degree of curatorial freedom, not only in terms of the historical episodes and objects selected, but also in the layouts and forms of their presentations. From Simon Fujiwara's archaeology of the present moment to Roger Hiorns' timeline of BSE/vCJD, the artists have designed their sections to be as visually compelling as the objects themselves.

1 See John Hills/John Ditch/Howard Glennerster (eds.), *Beveridge and Social Security: An International Retrospective* (Oxford: Clarendon Press, 1994), p. 18

2 Walter Benjamin, 'Theses on the Philosophy of History', in *Illuminations* (London: Pimlico, 1999), IX on Angelus Novus, p. 249

3 William Coldstream in letter to Dr John Rake, 8 March 1933, Tate Archives, quoted in David Curtis, *A History of Artists' Film and Video in Britain* (London: British Film Institute, 2007), p. 53

4 For a concise history of artist-curated exhibitions, see Elena Filipovic, 'The Artist as Curator', in *Mousse*, Issue 41, pp. 2–30

Engaging the post-war moment, Richard Wentworth applies the intuitive logic and material awareness that informs his own artistic work to weave a complex web of material drawn from art and life. He casts a wide net to bring together objects as diverse as the symbolically-charged panoramic *Festival of Britain* (1951) mural by Ben Nicholson, to a once ubiquitous Crown Merton 'double' aluminium pan, designed to minimise gas consumption by cooking two different foods on the same ring. The latter serves as a design-led reminder of the austerity then overshadowing Britain, and is evidence of the re-orientation of military factory production to support a burgeoning domestic industry. Eduardo Paolozzi, being equally artistic and mechanically minded, addressed this shift early in his pre-pop *Bunk* collages (1947–52, reissued as a print set in 1972). Visual memories and resonances also inform Wentworth's selection such that Barbara Hepworth's detailed studies of surgical operations remind us of the founding of the National Health Service, while a 1953 Pye V4 television that once carried the images of Queen Elizabeth II's coronation evokes the first live televised event to be viewed en masse.

For Wentworth, ideas of Britishness are related to the island nature of the nation. He therefore explores the coast as a location of cultural memory, from Robert Capa's blurred photographs of the D-Day landings on the beaches of Normandy, which were widely circulated in Britain through the *Picture Post* (and which were rehearsed on British beaches), to the Cold War armament of our own coastline with hundreds of Bristol Bloodhound surface-to-air missiles, all pointed north-eastward, in the direction of potential incoming Russian nuclear bombers. In between these two militarised bookends, one finds a plethora of coastal episodes, from the vibrant St Ives artist colony, to Henry Moore beachcombing for inspirational pebbles, to depictions of leisure by Henry Grant, L.S. Lowry and Richard Hamilton, among others. The coast was a threshold in flux, simultaneously a location for creativity, defence and leisure. Not to mention that one of those pleasure

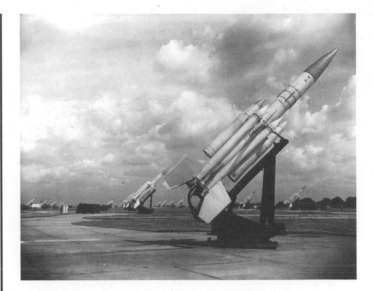

Bristol Ferranti Bloodhound I missiles on their launchers at Royal Air Force Station, Watton c.1983

5 John Ellis, *Blackpool at War: A History of the Fylde Coast During the Second World War* (Port Stroud, Gloucestershire: The History Press, 2013), p. 38

6 '...developing a greater knowledge, understanding and practice of the fine arts exclusively, and in particular to increase the accessibility of the fine arts to the public.' The ACFC is comprised of 450 films dating from 1953–98 and was donated to the BFI National Archive in 2011. Since 1986, the ACC has been managed by the Southbank Centre on behalf of Arts Council England

7 By the early 1970s, 'the BFI had been alarmed by the extent to which the Arts Council was stretching the definition of "arts documentary"'. Rodney Wilson had been appointed the first Film Officer in 1970. See the concise institutional histories described in Curtis, *A History of Artists' Film and Video*, pp. 53–84

'Perhaps not surprisingly, film
and photography – the two mediums that
held an uneasy relationship with
fine art even as late as the 1980s – were
not officially recognised in the
Arts Council of Great Britain's framework.'

destinations, the resort of Blackpool, was where William Beveridge penned his famous report as thousands of civil servants were relocated from London during the war.[5] With his sights on the shoreline, Wentworth engages with the dynamism and radical optimism that offset the austerity and poverty of post-war Britain.

In 1946, as a part of the institutions and programmes that the government established to better the lives of Britons, the Arts Council of Great Britain (ACGB) was established by Royal Charter.[6] ACGB was split into departments by art form, with the visual arts established around the traditional disciplines of painting and sculpture. On the one hand, the establishment of a national collection of contemporary British art was a way of directly supporting living artists through the purchasing of their artworks; on the other, circulating these and other artworks through exhibitions fulfilled the ACGB commitment to education and accessibility. Perhaps not surprisingly, film and photography – the two mediums that held an uneasy relationship with fine art even as late as the 1980s – were not officially recognised in the ACGB framework. But it is precisely for their experimental and innovative aspects that filmmaker John Akomfrah and photographer Hannah Starkey have engaged the Arts Council Film Collection and the photography holdings of the Arts Council Collection (ACC) respectively for their sections. For photography and film, the periods of flux through the 1970s and 1980s were highly fruitful in terms of avant-garde practice and, being documentary mediums, are also two of the best for providing a view onto the past.

In truth, it was less than a decade after its establishment that the Arts Council started to commission films. However, taking its lead from the Council for Entertainment, Music and the Arts (CEMA) that had preceded it, the Arts Council saw film as a purely documentary medium, and one that served a pedagogical purpose. The commissioning strand initiated in the 1950s thus included biographies of artists such as Francis Bacon, virtual tours of major exhibitions, and art historical 'lectures' that were then distributed by the British Film Institute (founded 1935). While Akomfrah acknowledges this early programming in his selection, he is much more interested in what he calls the 'protean' nature of the collection, in which the experimental use of the medium allows film to be considered as artwork in its own right. Films by Jeff Keen and Bruce Lacey, for example, exemplify this tendency for 'mission creep' in the artistic space between the commissioning and the submission of the finished film.[7] These works evidence a rising counter-culture in the 1970s, articulated through a challenge to the conventions of filmmaking. Through them, we can gain glimpses of not only art history, but also of the complex societal issues facing Britons

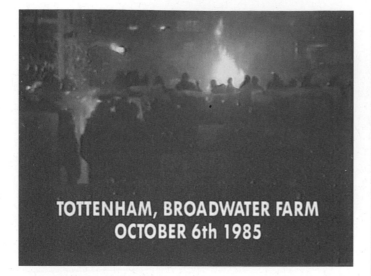

Rodreguez King-Dorset (dir.)
Winston Silcott. The beard of justice
1994

in recent times: *12 Views of Kensal House* (1984) follows the fragmentation of a housing estate community over three decades, while *Winston Silcott. The beard of justice* (1994) examines the wrongful conviction of a man in the wake of the Tottenham race riots in 1985. That the Arts Council commissioned these films demonstrates the rising urgency to engage with the political issues of the time, in particular as newly established independent film groups, as well as Channel 4, expanded broadcasting and distribution networks.[8]

While film had found a place, if a tightly conscribed one, on the Arts Council's early agenda, photography would have to wait until 1973, when the first Photography Officer was appointed, before becoming officially recognised as an active collecting strand.[9] The photographic image was a widely circulating cultural phenomenon by the 1970s and, in a way, so-called art photography structured and positioned itself in opposition to the profusion of advertising imagery. In approaching the ACC, Hannah Starkey has used the foil of commercial photography to select images that challenge the reductive nature and straightforward messaging of advertising from the 1970s to the 1990s. Starkey's own practice as an artist and commercial photographer informs her thinking about the constructed nature of the image. As such, her selection of photos asks the viewer to look closer and for longer

to unpack the visual intelligence of art photographers. Victor Burgin, Hipgnosis and Mitra Tabrizian take a critical look at the visual codes, tropes and stereotypes present in advertising, in a way mirroring the contemporaneous semiotic approaches developed by Roland Barthes and John Berger.[10] Starkey also focuses her attention on images that complicate our understanding of performing the everyday, in terms of dress (period fashions, formal attire, uniforms, etc.), familial and societal roles and responsibilities, and gender. Additionally, numerous portraits of individuals in scenes from across the United Kingdom knit together emotional undertones with a sense of place.

How people have related to locations and physical space over time is also a key focus of the section devised by Jane and Louise Wilson. Their interest in spaces with resonant histories provides a conceptual backdrop for their selection of work. The Wilsons' earliest area of interest is the mining town of Peterlee where Victor Pasmore designed the Apollo Pavilion (1967–70) and where, a generation later, Stuart Brisley initiated a project to create a living archive filled with the stories of local people.[11] At other locations across the United Kingdom, the Wilsons explore relationships that are more strained and, sometimes, violent, such as along the chain-link fence perimeter where the Greenham Common Women's Peace Camp protested the use of nuclear weapons during the 1980s, or more broadly across Northern Ireland (and indeed Great Britain) during the Troubles. In these episodes, history is writ large and the Wilsons have selected a few visually resonant artworks that point toward the sheer complexity of these situations. Further, in order to offset and balance these 'grand' narratives, the Wilsons have included works that examine space in a more intimate but no less compelling way: Christine Voge's photographs inside the first women's refuge for victims of domestic violence, Penny Slinger's surrealist collages of the female body juxtaposed with gothic architecture, and Mona Hatoum's *Measures of Distance* (1988), a personal meditation on exile and family. The relationship between memory and measurement, both literal and

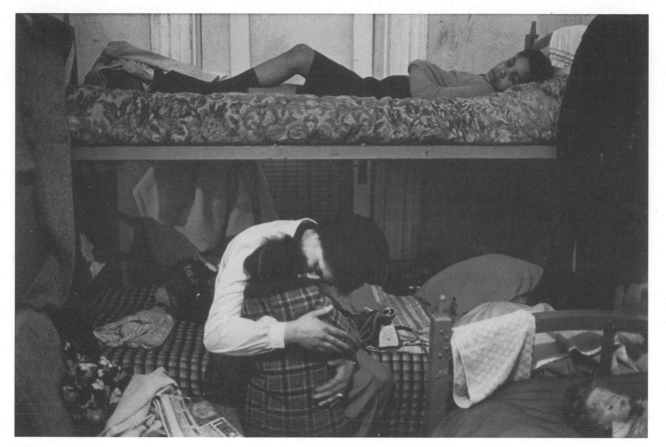

Christine Voge
Untitled
1978

8 Akomfrah co-founded Black Audio Film Collective in 1982 and later served on the Arts Council Film committee

9 At over 2,000 photographs, the medium comprises around a quarter of the overall ACC holdings

10 Roland Barthes, 'Rhetoric of the Image', available in English in Stephen Heath (ed./trans.), *Image, Music, Text* (New York: Hill and Wang, 1977), pp. 32–51 and John Berger, *Ways of Seeing* (London: BBC Books, 1972)

11 Started in 1974, the project was not completed due to differing artistic intentions between the Artist Placement Group/Brisley and the local council. See APG papers in Tate Archive 20042/1/3/45

12 Two large measures made by the Wilsons, 'Blind Landing' Lab 1 and 'Blind Landing' Lab 4 (2012), intersect the gallery space and are based on the obsolete imperial yardstick. These refer to measuring scale in filmmaking as well as to scales of measurement in Cold War H-bomb test chambers on Orford Ness, Suffolk

13 Pathogens known in the 1970s included bacteria, viruses and fungi

metaphorical, underpins many of the works that the Wilsons have brought together, as they examine how people relate to the ways in which the world changes over time.[12]

In his section for the exhibition, Roger Hiorns takes a research-led approach to a dark episode in recent history: the epidemics of bovine spongiform encephalopathy (BSE) and its human equivalent, variant Creutzfeldt-Jakob disease (vCJD). Hiorns' investigation follows the tragic narrative of modern farming, the implications of which reverberate through scientific, political, cultural, agricultural, medical, culinary and media spheres in Britain to the present day. For three decades, the livelihoods of farmers across the UK, as well as much of the food industry, were held in balance by a small government team tasked with taking action against an unknown enemy. The outbreak of BSE led to the ground-breaking discovery of the prion, a new type of pathogen previously unknown to scientists.[13] And even though the crisis peaked in Britain during the 1980s and 1990s, this prion-based disease links together temporally and geographically

'Overhanging this episode in British history is the uncomfortable existence of the modern, over-optimised food production chain in which, in the words of John Berger, "every tradition which has previously mediated between man and nature was broken".'

Robert Bygott (dir.)
Kuru: The Science and the Sorcery.
Dedicated to the Fore and other people who suffered
from the kuru epidemic in Papua New Guinea
2010

disparate moments – from the first recorded instances of scrapie in sheep in the eighteenth century, to the cannibalistic Fore tribe in Papua New Guinea who suffered from the shaking disease kuru, to the present crisis of chronic wasting disease in deer across North America. Leading scientific research connected these narratives as the epidemic unfolded; one of the first things British scientists did in 1996 when they established a link between vCJD and BSE was to travel to Papua New Guinea to consult the decades of field research notes on kuru.[14]

Overhanging this episode in British history is the uncomfortable existence of the modern, over-optimised food production chain in which, in the words of John Berger, 'every tradition which has previously mediated between man and nature was broken'.[15] Cows, natural herbivores, were made to eat other cows. The rupture in the chain that caused BSE reveals a deep-rooted structural problem, one that, in Hiorns' mind, illustrates a kind of 'systemic violence'.[16] In order to investigate the complexities of the system, as well as evidence the research-led nature of the

project, Hiorns not only looks at objects, but also the masses of minutes, reports and correspondence that attest to the developing situation, in particular by the Spongiform Encephalopathy Advisory Committee (SEAC) and the National CJD Research Surveillance Unit in Edinburgh. While the tight economic relationship between production, consumption and profit that led to the BSE crisis continues to be part of Britain today, a few positive legacies can be identified – the episode spurred the nation on to better cuisine, led to tighter legislation governing food production and gave rise to a generation of celebrity chefs.[17]

The rise of celebrity culture is but one strand that Simon Fujiwara has examined in his backyard 'archaeology' of present-day Britain. Choosing equal amounts of artworks and cultural objects, Fujiwara examines our society in a period of late capitalism; one in which visual art, architecture and fashion are inextricably linked to entertainment, technology, conspicuous consumption and a postmodern sense of wellbeing. For Fujiwara, the intertwining of these economies is, in

Britain, the result of the monetarist and economically liberal policies set into motion by Prime Minister Margaret Thatcher and her Conservative government during the 1980s. These policies continued to hold sway during the 1990s as a part of Tony Blair's 'Cool Britannia' – a resurgence in British cultural pride, inspired by the swinging sixties and heavily backed by the government's publicity machine. Under Blair's government, the Young British Artists rose to fame, themselves no less a part of this mixing of celebrity and enterprise culture. Footballer David Beckham, actress Tilda Swinton, and the band Blur all starred in artworks during this time, and by the millennium, British contemporary artists were making some of the most famous, controversial and expensive art in the world.

Simultaneously, as these hyper-commodities appeared, other things started to disappear or dematerialise under Britain's late capitalism: the nation re-orientated from a resource and production economy to a service, financial, and experience economy. The rise of soft economics now allows everything from our experiences to our lifestyles and wellbeing to be valued and monetised.[18] And yet, much of this commoditisation remains aspirational, a potentiality that we are repeatedly invited to fulfil, but which is constantly out of reach – an affective condition that theorist Lauren Berlant calls 'cruel optimism'.[19] Seen this way, it is more than the stock market that links the defaulting sub-prime mortgages that precipitated the 2008 financial crisis in the US to the widespread riots and looting across Britain three years later – both involve the desiring of aspirational lifestyles. Today's Britain is not only hyper-linked to the global economy, but is also enmeshed in the 'promise of the object' on which late capitalism is predicated.

Back in 1945, British optimism came with a heavy price. At the end of the war, with the homeland in ruins and with troops and the remnants of empire still stretched around the world, Britain was on the brink of financial collapse.[20] Economist John Maynard Keynes was sent to the US to negotiate a financial aid package and returned home

14 The Medical Research Council Prion Unit, UCL Institute of Neurology, maintained a research field unit in Papua New Guinea between 1996 and 2012

15 John Berger, 'Why Look at Animals?' (1980), in John Berger, Why Look at Animals? (London: Penguin Books, 2009), p. 12

16 Slavoj Žižek, Violence (London: Profile Books Ltd, 2008), p. 1

17 In 2001, the Department for Environmental, Food and Rural Affairs (DEFRA) and the Food Standards Agency (FSA) were both founded

18 See essay by economist Daniel Fujiwara in this catalogue

19 Lauren Berlant, Cruel Optimism (London: Duke University Press, 2011)

'The notion that optimism both bookends
and filters through the past 70 years
of modern British history is something to
be both celebrated and critiqued.'

with a loan of over one billion pounds (£159 billion in today's money). This money averted disaster and sustained Britain's recovery and growth for the next half century; remarkably, the final £43-million payment for that loan was sent by wire from Tony Blair's government to the US Treasury in 2006.

Drawing upon those American funds in 1946, the Council of Industrial Design organised an exhibition at the Victoria & Albert Museum aimed at boosting the morale of the British people. Entitled *Britain Can Make It*, the show revelled in innovative design, manufacturing techniques and product distribution, daring at times to imagine a better future – a future made better mostly through shiny technological *things*.[21] Britons, looking to forget the past and to dream of the future, responded in droves; by the time the exhibition closed after its twice extended, three-month run, an astonishing 1.4 million people had attended. Conspicuous consumption had been given a platform, and the press also responded with its own version of cruel optimism – in austerity Britain, the show was dubbed 'Britain Can't Have It'.

The notion that optimism both bookends and filters through the past 70 years of modern British history is something to be both celebrated and critiqued. It is one thread alongside many others – from economics, policy-making, and conflict to neighbourhoods, daily habits, and food – that pulls through the different sections of *History Is Now*, connecting them. The themes and episodes chosen by the seven artists fold over and slide alongside one another, bridging conversations and drawing out themes across time and place. And yet the overall exhibition is not a comprehensive retelling of British history, but instead an attempt to remember the past specifically and unconventionally through the eyes of artists, and – perhaps optimistically – to understand how and why we got from there to here.

20 By 1941, Britain was already almost bankrupt, as Churchill had sent its cash reserves to the US – literally, by shipping barges of solid gold bars across the Atlantic – in exchange for arms, equipment and supplies

21 *Britain Can Make It* was envisioned in 1942 by the Post-War Export Trade Committee to be a trade show to boost industry and exports, but by the time the exhibition was staged it had been re-orientated to the general public as a patriotic celebration. See Patrick J. Maguire, 'Patriotism, Politics and Production', Maguire/Jonathan M. Woodham (eds.), *Design and Cultural Politics in Post-War Britain: The Britain Can Make It Exhibition of 1946* (London: Leicester University Press, 1997)

Richard Wentworth

'I was intrigued by Nicholson painting the coastline
of a particularly pleasant part of England,
while off the coast of Normandy there were men
drowning, overladen with equipment:
something that Robert Capa's Rauschenberg-esque
photographs are witness to.'

There is an interesting gap between the correctly curated show – with its very punctilious hanging – and the space that artists operate in. I wanted the impression in this show to be, as much as possible, true to the experience of being alive. Our lived experience of the world is, after all, of everything overlapping and constantly colliding. The way that time, place and physics weave together is something that art history denies, or doesn't often make space for. This exhibition enjoys these connections and associations, tracing links between domestic life – in all its humdrum modesty – and military advancement and technological change. In the array of objects and artworks on show, we move between the austerity of the post-war years and the optimism of the late 1950s and from there to the gloom and paranoia of the Cold War. Public and private collide: Henry Moore's pebbles, collected along the British shore, sit side by side with Robert Capa's photographs of the Normandy Landings, while outside on the balcony looms the now impotent Bloodhound missile, no longer protecting coasts and borders but rather our, sometimes fragile, sense of national identity.

One of my hopes with this exhibition was to bring attention to the beach, a site that during this period is associated as much with defence, heroism and death as with free time, pleasure, sunshine and sexuality. It was the sheer domesticity of a wartime Ben Nicholson Cornish harbour view that first sparked my interest in Britain's beaches in the years immediately preceding and following 1945. I was intrigued by Nicholson painting the coastline of a particularly pleasant part of England, while off the coast of Normandy there were men drowning, overladen with equipment: something that Robert Capa's Rauschenberg-esque photographs are witness to. Apparent contradictions such as this – the beach as a place of pleasure, as well as warfare – always co-exist. You only have to pick up a diary, or some other piece of modest domesticity in a junk shop, to see that people's lives continue as ever before, even when there is a war on.

I wanted the effect of the inclusion of advertising in this exhibition to be a little like waiting for the train; as you wait, you read the posters and you start thinking 'What exactly is advertising? How does it work?'. In publications of the day, as now, editorial content was cheek-by-jowl with advertisements promoting all those little things that tell us who we are and who we want to be. It is in the combination of content and advertising that we get a fuller sense of the values of the period. Eduardo Paolozzi 'borrowed' from advertising to make his *Bunk* collages (1947–52), which are precursors of pop art. Britain itself is a nation of borrowers. We have borrowed people, food, culture and ideas.

A good Henry Moore sculpture comes from carving, peeling, or whittling: from what we might call 'elbow work'. I like the tactility and thoughtfulness of Moore's stringed figures; they 'rhyme' with the feeling of a pebble in the hand, and suggest skin to skin contact. In the late 1960s I was working for Moore as a studio assistant. I remember being in his studio one day, mixing plaster with the radio on. Suddenly, the news reader announced that the first ever heart transplant had taken place. Back then, that news was completely shocking. Now of course, it feels more like straightforward medical plumbing. I want to suggest, with this exhibition, that military, medical and technological developments are intricately connected: the washing machine that my dad brought home from work at English Electric in 1953, for example, can be seen as – effectively – a domesticated Spitfire.

While I missed *Britain Can Make It* – the exhibition of industrial and product design held at the Victoria & Albert Museum in 1946 (not being conceived until 1947) – I like the sense it had of a rousing village fete; a mood that the Millennium Dome, for example, singularly failed to achieve. I selected the objects and the graphics from this show for the confidence they suggested about craft, problem solving and addressing one another in a fresh and 'modern' way. I don't hold with this optimism myself; I have experienced the foolishness of my own desires, and witnessed generations of people coming up with the newest supposedly 'problem-solving' gadgets. In the course of my lifetime alone we have moved from the mangle to the washing machine to the wet room, and from the crystal set to the valve radio to the iPhone.

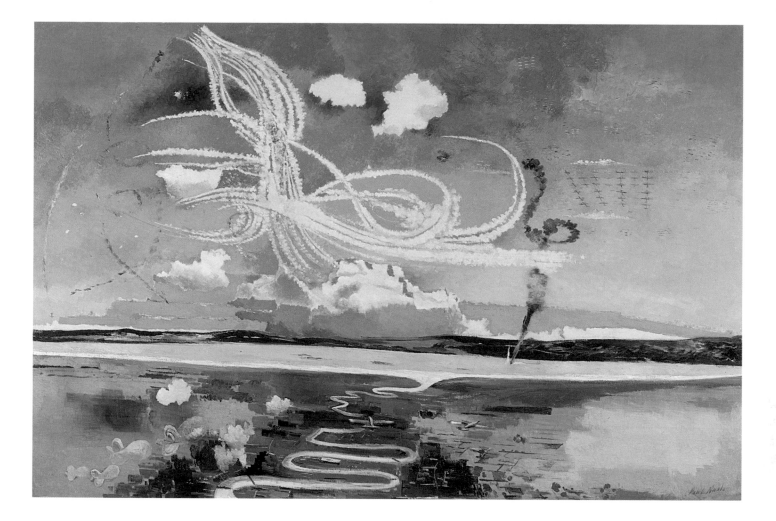

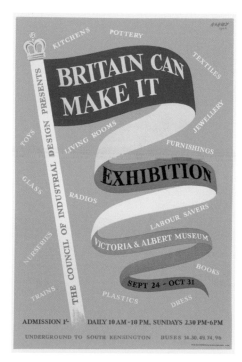

Paul Nash
Battle of Britain
1941

Ashley Havinden
Britain Can Make It
Designed for the V&A
1946

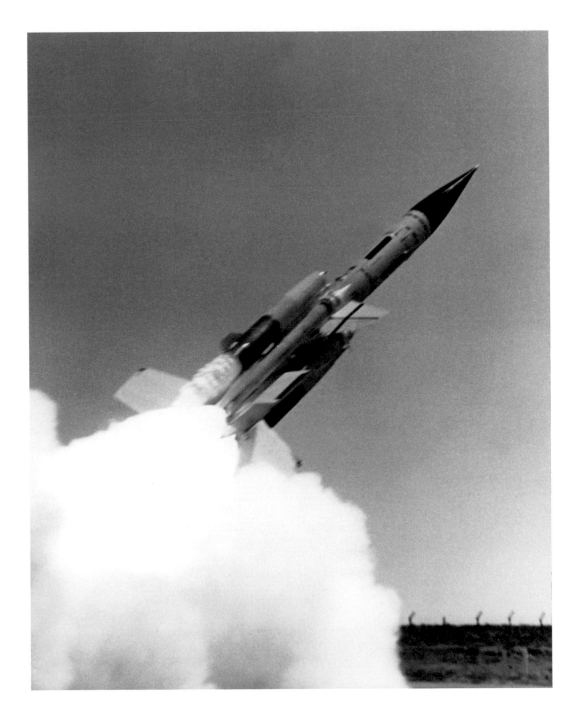

Bloodhound Mk.2 Surface-to-Air Missile,
Bristol Aeroplane Co.
Test launch, Woomera, Australia
1964

Eduardo Paolozzi
Take-off
Bunk – collage 1947–52
1972

Eduardo Paolozzi
Fantastic Weapons Contrived
Bunk – collage 1947–52
1972

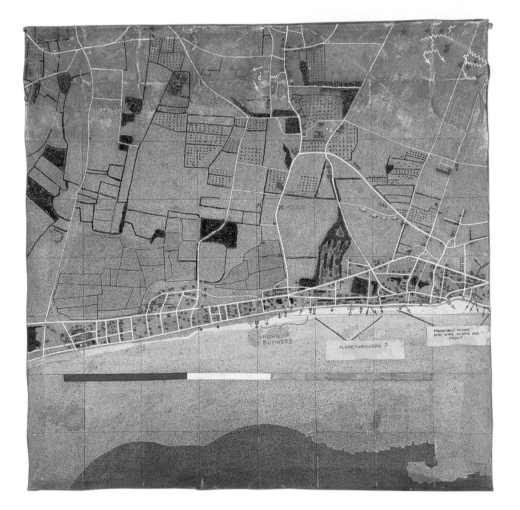

War Office
Briefing model of Juno and Sword Beaches for D-Day Landings
Coastal section centered on Langrune-sur-Mer
1944

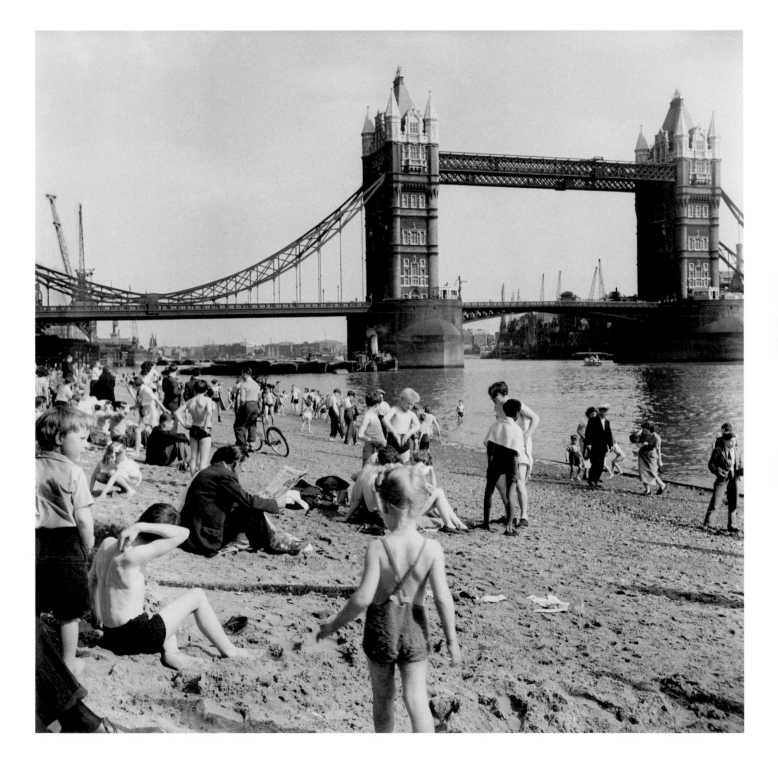

Henry Grant
Londoners relax on Tower Beach
1952

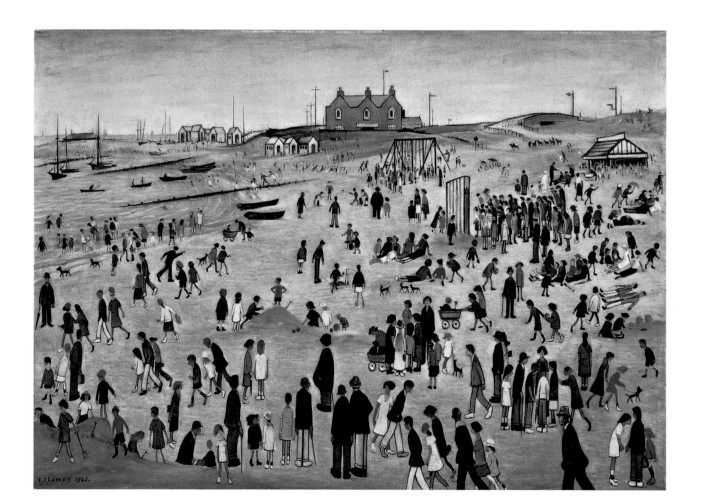

L.S. Lowry
July, the Seaside
1943

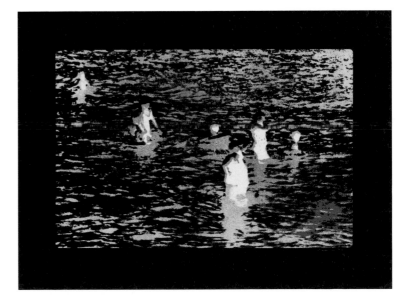

Robert Capa
American soldiers landing on Omaha Beach,
D-Day, Normandy, France, June 6, 1944
1944

Richard Hamilton
Bathers
1967

Eduardo Paolozzi
It's a Psychological Fact Pleasure Helps Your Disposition
Bunk – collage 1947–52
1972

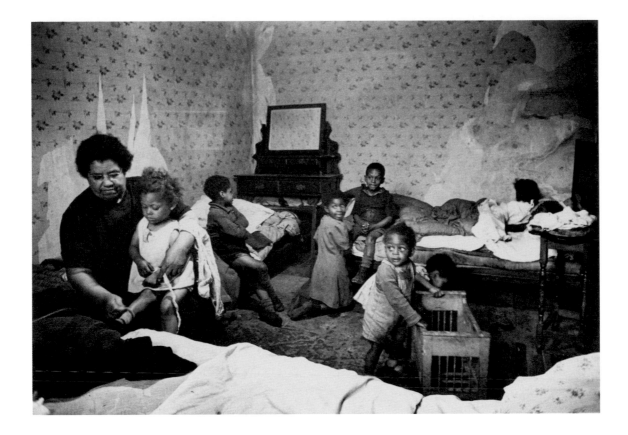

Bert Hardy
Overcrowding in Liverpool. Mrs Johnson in the bedroom
shared with six grandchildren
1949

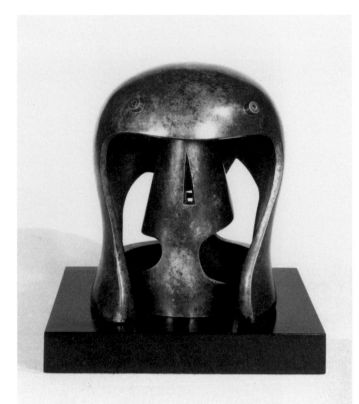

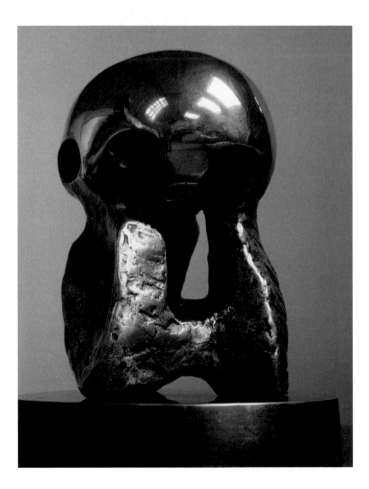

Henry Moore
Maquette for Atom Piece
1964, cast 1970

Henry Moore
Helmet Head No. 1
1950

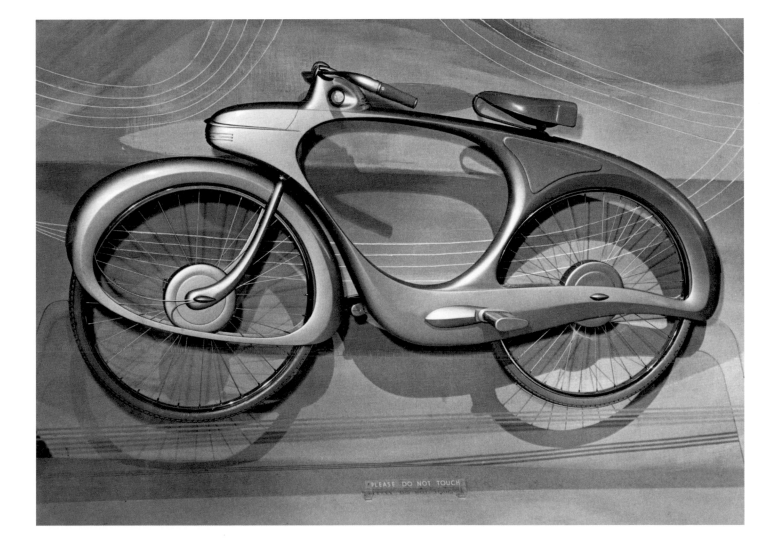

Ben Bowden
Prototype electric bicycle
Displayed in 'Designers Look Ahead'
Britain Can Make It, *Victoria & Albert Museum*
1946

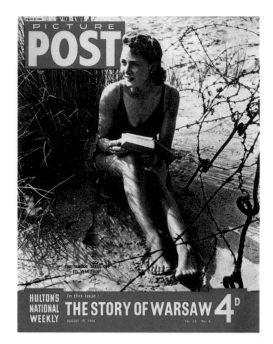

Crown Merton *Picture Post* Eduardo Paolozzi
Double saucepan 19 August 1944 *Improved Beans*
c.1960s Bunk – collage 1947–52
 1972

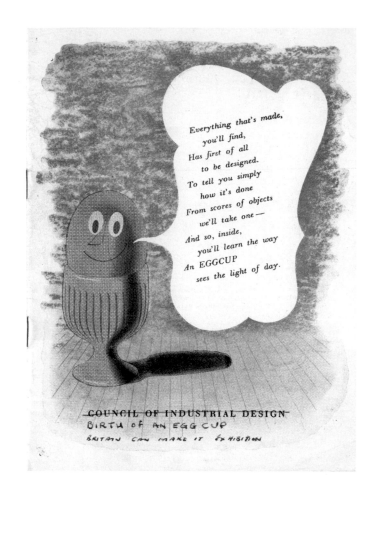

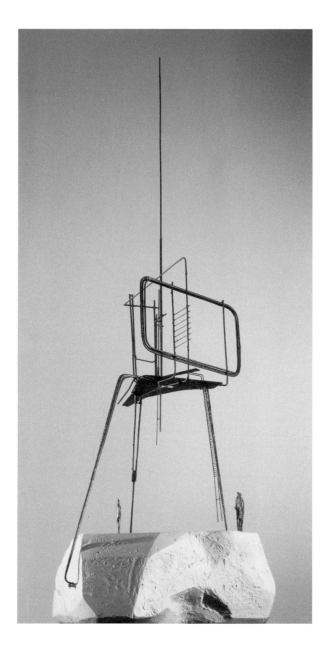

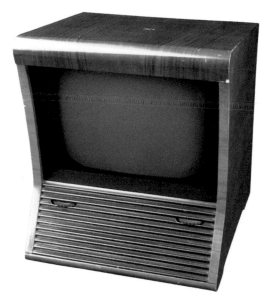

Design Research Unit with
Council of Industrial Design
Birth of an Egg Cup
1946

Pye Ltd
*V4 Black and White Television
Receiver*
1953

Reg Butler
*Working Model for 'The
Unknown Political Prisoner'*
1955–56

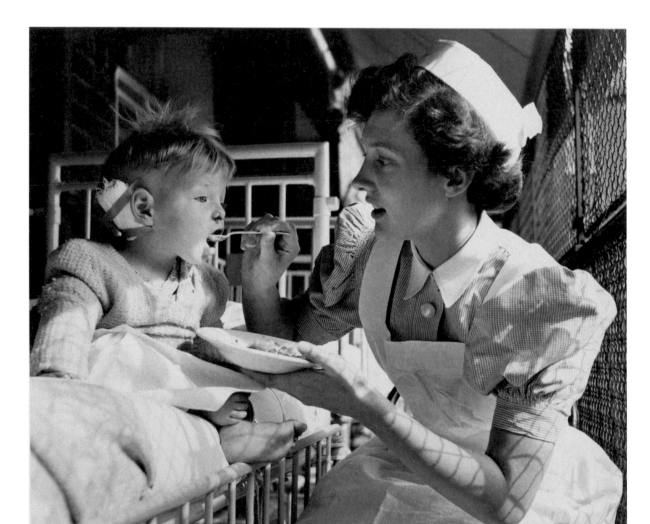

Bert Hardy
A student nurse feeds a child recovering from a mastoid operation
1953

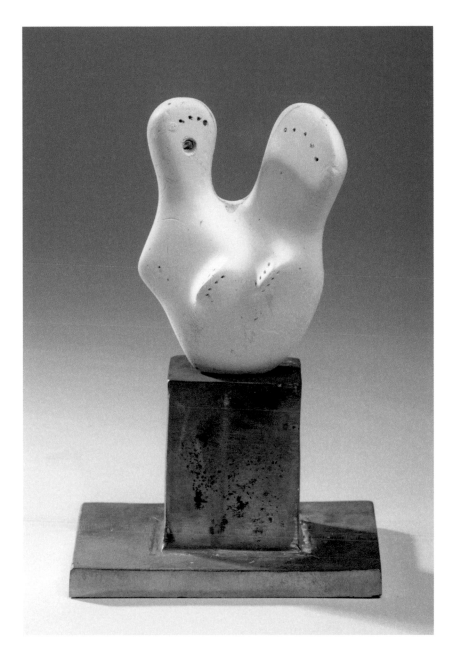

Henry Moore
Maquette for Mother and Child
1938

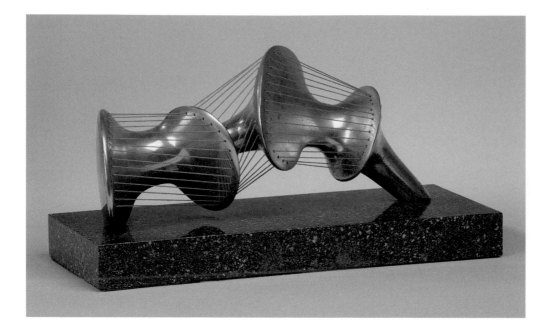

Henry Moore
Stringed Figure
1939

Barbara Hepworth
Hand II (horizontal)
1949–50

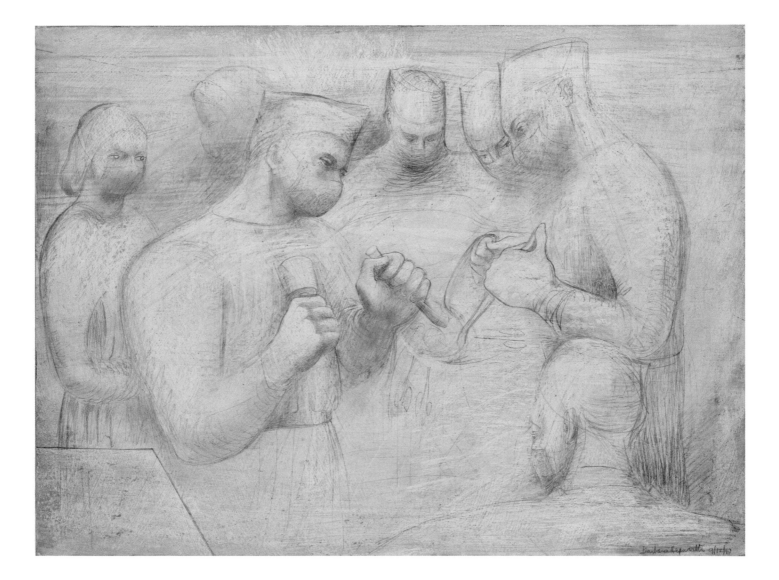

Barbara Hepworth
Reconstruction (Hospital Drawing)
1947

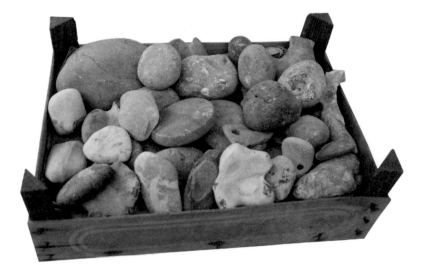

Henry Moore
Stones and pebbles collected by the artist

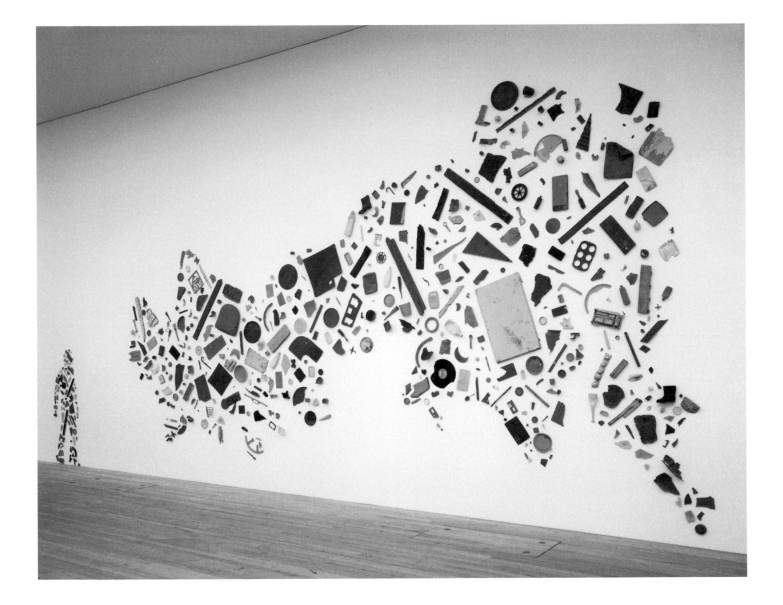

Tony Cragg
Britain Seen from the North
1981

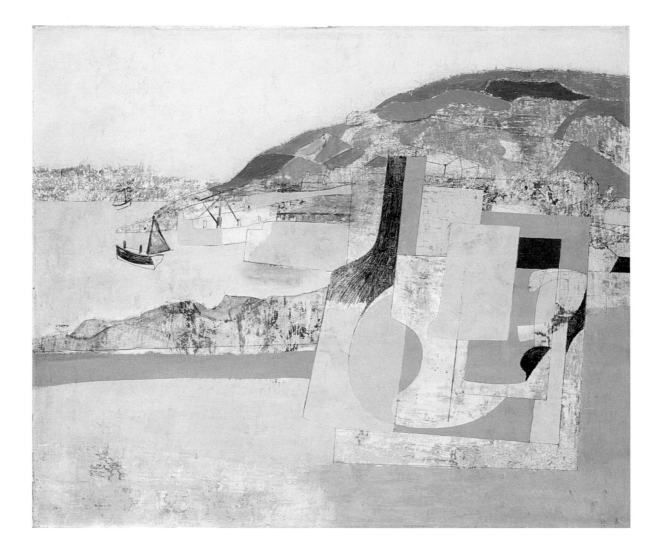

Ben Nicholson
November 11–47 (Mousehole)
1947

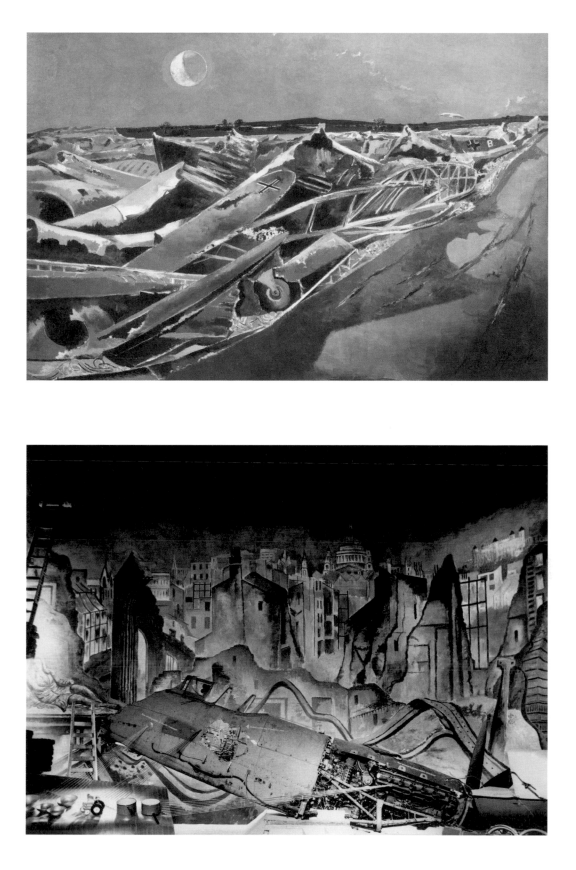

Paul Nash
Totes Meer (Dead Sea)
1940–41

Background display
'War to Peace'
Britain Can Make It, *Victoria & Albert Museum*
1946

Warfare/Welfare
and the Coasts of Britain

'The iconography of World War II had given a special
place to the dedicated team – the air-crew, the platoon.'

Warfare state technologies had the effect of transforming the British cultural imagination in the period after 1945. In engineering and in electronic fields, advanced techniques developed during the war became imprinted on the arts. In 1951, the Festival of Britain exemplified this influence: visitors arrived at the site from the North Bank of the Thames over a British Army Royal Engineer's modular-built, metal alloy Bailey Bridge – which had been spanning battle-spaces in Italy, France and Germany since 1942. If visitors went on to have refreshments in the Festival's Riverside Restaurant and to view Ben Nicholson's specially painted concave mural installed there, they sat under a prefabricated aluminium roof which had been quickly assembled using RAF aircraft riveting techniques. Nearby, a radar dish, developed from the technology which detected Nazi bombers while they were still far off the British coast, was fitted to the top of a Victorian relic – a shot tower – and bounced electronic signals off the moon. The restaurant's architect, Jane Drew, was already using military-industrial technology in pre-fabricated kitchen designs: the domestic sphere co-existed with and spun-off well-funded advanced military technologies.

At this time, built structures were heavily invested with utopian social hope. The role of the consultant structural engineer in architecture had been enlarged by the audacity of practitioners such as Felix Samuely who solved the problem of suspending the Skylon over the Festival of Britain. Wartime 'temporary architecture', used for propaganda displays in civic spaces by the Ministry of Information and the Army Bureau of Current Affairs, depended on prefabricated elements which carried over into post-war building practices and were evident throughout the Festival. By the beginning of the 1960s, the architecture of James Stirling would rely upon the cantilevered structures of structural engineer Frank Newby, a pioneer of 'vertebrate building'. Bodies as well as built structures were the focus of utopian visions and Newby's bodily metaphor of bone exemplified a crucial

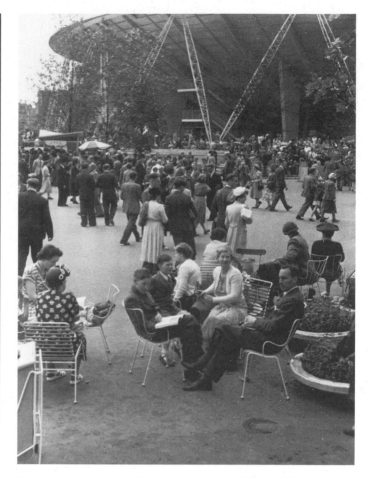

Visitors to the Festival of Britain in front of the Dome of Discovery 1951

motif of the period. The site of orthopaedic medicine – remedial work on human skeletal and muscular systems – became a spectacular thematic for Barbara Hepworth, particularly in her graphic representations of skilled surgical teams at the time of the birth of the National Health Service.

The iconography of World War II had given a special place to the dedicated team – the air-crew, the platoon – and Hepworth's hospital drawings of 1947–48 disclosed co-ordinated sets of monumental medical protagonists joined in noble effort. Surgeons such as Norman Capener, who in 1944 had performed intricate operations on Hepworth's daughter, Sarah, for osteomyelitis – an infection of the bones – found their apotheosis as sublime representatives of the values of humane scientific professionalism. Hepworth's pictures seemed to incarnate an ideology of universal

'Beside the many wartime medical advances in pharmaceuticals – penicillin, for example – there were also electronic technologies, accelerated by the need to develop radar to detect aerial raiders off the British coast, which were then transferred back into the medical sphere, with the hearing aid being one such prosthetic.'

THE NEW

NATIONAL HEALTH SERVICE

*

Your new National Health Service begins on 5th July. What is it? How do you get it?

It will provide you with all medical, dental, and nursing care. Everyone—rich or poor, man, woman or child—can use it or any part of it. There are no charges, except for a few special items. There are no insurance qualifications. But it is not a "charity". You are all paying for it, mainly as taxpayers, and it will relieve your money worries in time of illness.

'The New National Health Service' leaflet 1948

humanism which had been adopted by the Western Allied United Nations; this, at least, was the view of Herbert Read, who saw the hospital drawings replenishing '… one's love for life, humanity and the earth'. This benign universal vision also had its uncanny side: the archaic traces, the priestly bearing, the rapt looks and ethereal auras with which Hepworth coded the staff in the operating theatres, showed an other-worldly order. The topic of celestial care and oversight figured in Michael Powell and Emeric Pressburger's super-modern heaven in their film *A Matter of Life and Death* (1946), where a heavenly staff-officer displayed a piercing, 'more-than-human', gaze when dealing with recently mortal RAF and USAAF bomber-crew fatalities, handing them angelic wings in hygienic settings.

Hepworth was also specific, even forensic, in her representations of bodily care: her welfarism evolved from the restoration of the body to more specific medical and surgical case studies. In April and May 1948 Hepworth spent time drawing the surgeon Garnett Passe at the London Clinic, where he was performing fenestration of the ear – making openings in the labyrinth of the inner ear to restore hearing. To the derision of High Tories, such as Evelyn Waugh, the newly born National Health Service, which came into being in July 1948, made free and universal provision for all surgical

procedures and remedial technologies, including prosthetics, such as false teeth and hearing aids. Beside the many wartime medical advances in pharmaceuticals – penicillin, for example – there were also electronic technologies, accelerated by the need to develop radar to detect aerial raiders off the British coast, which were then transferred back into the medical sphere, with the hearing aid being one such prosthetic. As the 1950s began, the cumbersome vacuum valve used in electronics was starting to give way to the tiny transistor. For the manufacture of electric circuitry, this had a miniaturising effect, so that by 1955 hearing aids were increasingly augmented with them and one English electronics manufacturer, Mullard, produced the OC71 low-frequency germanium PNP transistor for them. By a sideways, make-do-and-mend initiative, Maurice Gribble, an electronics engineer working at Ferranti's Wythenshawe plant, re-directed their use to produce a 'hearing aid computer', which he demonstrated to the Duke of Edinburgh in 1957. By the close of the 1950s, Gribble and Ferranti had taken a final step and masterminded an epochal civilian computer, the Argus 200.

This offered direct digital control of production processes – an enormous step in the burgeoning modernisation of British industry. It was symptomatic of the dynamics of the advanced industrial warfare state, since Wythenshawe's research was divided equally between military and civilian uses of computers. The Argus 200 had two destinies: in May 1962 it was first put into operation at ICI's Alkali Division at Fleetwood for directing the civilian chemical process of producing soda ash for cosmetics and medicinal purposes. But by October 1963 it had become the 'brain' of the Launch Control Post which guided Britain's most advanced RAF missile, the surface-to-air Bristol Bloodhound Mark 2. Cantilevered up on hydraulic rams, the white-painted Bloodhounds were posted down a chain of launch sites running along the east coast from the Humber to the Thames. This was intended to be the first line of defence against Soviet bombers bringing

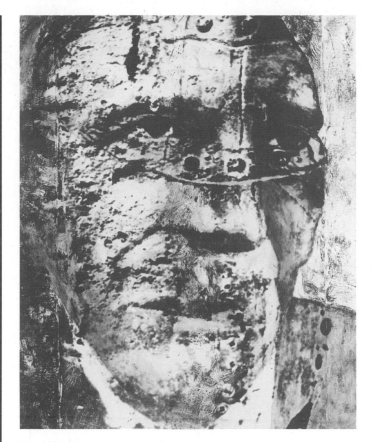

Nigel Henderson
Head of a Man
1956–61

thermonuclear bombs to attack Britain during the Cold War, a function that it continued to serve until May 1990. Just as the mute observer in Tony Cragg's *Britain Seen from the North* (1981) vigilantly scans a ragged coastline and country made up of disparate ruins of salvaged consumer parts, so the outline of the Bloodhound missile itself, soon after launch, broke up into discards – its boosters falling away as burned-out detritus, leaving the rocket to home in on its nuclear target over the North Sea, guided by a version of the Argus computer.

The detritus of British modernity was loaded with pathos. One example was the abject remains of breakfasts and dinners featured in the mid-century segmented compositions of John Bratby. When this painter completed his *Still Life with Chip Frier* (1954) he proceeded with a dumb factualist oil-paint

'The detritus of British modernity was loaded with pathos.'

patchwork of manual kitchen objects, utensils and commercial food in dull packaging. Stubborn episodes of ruins were a large feature of the post-war imagination which looked forward anxiously to an even greater ruination by nuclear weaponry. Nigel Henderson offered the epitome of this in his large collage, *Head of a Man* (1956–61). Here was a recognisable human face made up of a Frankenstein set of 'small blotches and blisters… patch and stain'. Such abrasions were everywhere in post-war British art and culture. Even Hepworth's supra-human surgeons are built from such scratches and shadows; Nicholson's mural for the Festival of Britain extended his repertory of distressed, pale visions of a fading geometric order. For the Whitechapel Gallery's *This Is Tomorrow* show in the autumn of 1956, Henderson sited his *Head of a Man* in a mocked-up Bethnal Green garden shed, its roofing made of the latest building material: transparent corrugated plastic. An RAF Coastal Command dive-bomber pilot from 1939 to 1942, Henderson understood the perception of detail in his collages as being analogous to his experiences of scale and distance when his aircraft dived down to bomb German U-boats in the North Atlantic and Western Approaches. His flying career was brought to an abrupt close when in a moment of terror and confusion he flew his bomber straight at cliffs on the north-west Scottish coast – he was able to pull up at the last minute and he and his crew miraculously survived.

Apprehensions of airborne disaster and threats of invasion were at the heart of the most notorious British sculptural project of the mid-1950s, Reg Butler's maquettes for *'The Unknown Political Prisoner'*. In March 1953 this was the winner of a quintessential Cold War cultural project, a sculpture contest financed – at arm's length – by a Central Intelligence Agency operative. At the base of his construction Butler placed 'witness' figures who strained their heads upward to scour the skies under filigree screens resembling radar arrays. In a short BBC TV documentary on the artist, made in 1958 (one of the first to be accompanied by electronic music's 'unheard sounds'), Butler spoke of living close to the de Havilland airfield at Hatfield and his excitement watching new delta-wing fighter jet designs tested: 'I spent much of my time staring up into the sky watching these planes being put through their paces. It may be significant that not so long after that I found that I was modelling heads looking straight up into the sky… I think it is reasonable to imagine that one is liable to project into the sculpture feelings that are going on in one's own body.' Butler was fascinated by new fantasy arenas of the technological age, seeing in their decor the basis for his art: 'I'm very excited by what is usually called science-fiction…' He sought out extraordinary vantage points for the sculpture's finished, gigantic version, *Working Model for 'The Unknown Political Prisoner'*: he wanted to place one on the surviving Berlin anti-aircraft tower, the *Flakturm* at Wedding, but he also contemplated them placed high on the White Cliffs of Dover, where they would look across the Channel and query the air which might once again be populated by threats to Britain.

Jane and Louise Wilson

'We are interested in crossing thresholds; in stepping across perimeters and entering different zones.'

We have looked closely at three sites of conflict and contention during a particular moment in history through the prism of how artists at the time responded to them. The artworks we selected were made within very specific parameters and contexts. In gathering them together we have been mindful of their original contexts, as well as the fact that a selection like this can never be representative of a total body of work. These objects and artworks shouldn't function as artefacts or relics: by bringing them together we hope to draw attention to the energy and momentum inherent in what are, for us, extraordinary artworks, objects and documents.

Victor Pasmore's Apollo Pavilion caused a great deal of controversy when it was first completed in 1970 – particularly in Sunny Blunts, the estate where the pavilion was erected. When we visited the pavilion in 2002 we found it overgrown and covered in moss: litter lined the undercroft and the upper part of the structure was completely sealed off. In 2011 the pavilion became a heritage site and was granted Grade-II listed status. This forced the local council to begin to engage with the structure. Partly because we grew up in that area of the country, we have a very strong sense of connection to Pasmore and to the impact that he had on the area; he is still the only artist ever to design and oversee the building of a new town in the UK.

In 1998 we made a piece of work called *Gamma*, filmed in one of the silos on the Greenham Common air base – a site on which, during the Cold War, Britain and the US planned to house cruise missiles as part of a NATO alliance. Growing up in the 1980s we were struck by the women's peace camps that grew up around the common's perimeter fence. While we were there in 1998 we saw what a physical ordeal it was to get inside one of these bunkers; to get access you first had to move a massive concrete slab. Despite these difficulties we discovered that one of the protestors had managed to get in and, once inside, to cut her hair. We loved that gesture: it was such a defiant act of transgression, a performance. We are interested in these kinds of performances and gestures, in crossing thresholds, in stepping across perimeters and entering different zones.

It has been fascinating for us to learn more about a generation of artists who came before us, artists such as Christine Voge and Penelope Slinger. Slinger – who has recently started exhibiting again – has a longstanding interest in the female body and its relationship to architecture. In her film *Lilford Hall* (1969) she works within a recognisable Gothic tradition, but manages to be confrontational and playful too. In contrast, Christine Voge was embedded within protest movements and places such as the first women's refuge; her work is concerned with social relations and social struggles. It seemed to us that Stuart Brisley bridged the two approaches of these women with his work *Beneath Dignity* (1977), which acts both as a performance and a protest.

Richard Hamilton, Conrad Atkinson and Rita Donagh made work directly about the Troubles in Northern Ireland. Combining conceptual art with political activism, Atkinson's *Northern Ireland 1968 – May Day 1975* (1975–76) was banned from being exhibited in the 1970s, in part because any mention of the Troubles suggested sympathy on the part of the artist with the bombing of innocent civilians. Rita Donagh used forensic precision in her aerial views of the H-Blocks near Maze, County Down – her aesthetic eerily foreshadows the perspective of drone technology.

Finally, Orford Ness is an island off the Suffolk coast that used to be owned by the Ministry of Defence. Its purpose-built laboratories were used for military testing during the Cold War. Using centrifuge and water pressure, scientists and technicians tested the strength of the casing of the hydrogen bomb. In 2012 we installed *'Blind Landing' Lab 1* and *'Blind Landing' Lab 4* – large measures based on the Imperial yard – in the island's disintegrating laboratories; their lengths representing the span of the hydrogen bomb test chambers. The yardstick – once used in the construction of set building for the purpose of filmmaking – is, like the Empire, now obsolete.

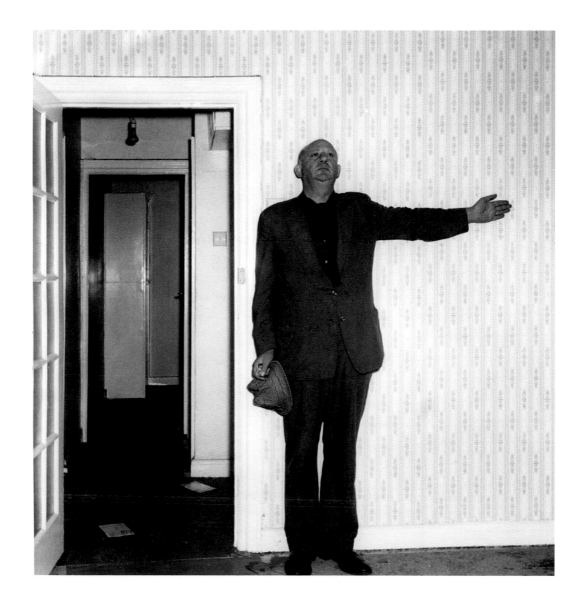

*Research photograph for Stanley
Kubrick's unfinished film* Aryan Papers
c.1939–59

ON GOING TO PRISON

Through my involvement in the Peace Movement and specifically my participation in Non Violent Direct Action, I have come to spend a considerable amount of time in prison for one thing or another. I feel I have learned a tremendous amount from these experiences, but there are some points that I feel every woman ~~should~~ involved in the peace movement and NVDA should consider before deciding on fine/bail refusal as a political stance in opposition to Nuclear Weapons.

The majority of women in prison have not had the chance of choosing to either pay a fine, accept certain bail conditions or else go to prison. In this instance we are more privaliged than an amazingly large proportion of women who find themselves facing imprisonment. Although I feel I have NO CHOICE other than to oppose Nuclear Weapons in whatever NonViolent way I can, I still recognise the differen between what must / to some women seem like voluntary imprisonment, and an altogether enforced one. Some of the women I met whilst in prison recalled instances of encountering women from the Peace Movement who had annoyed them by acting in an almost 'holier than th way towards other women. Almost every woman I met whilst in prison was imprisoned for one of three reasons. Either she had not conformed to 'societie's' image of a woman hence ~~she~~ is scapegoated i order to set an example for other women (and to protect men's position) or she has been forced through circumstances beyond her control into using whatever means are at her disposal in order to survive or feed her children. The authorities see fit to call these means of survival illegal and label her a criminal; or because ~~she~~ has defended herself against male violence, and as the state chooses to condone male violence in one for or ~~another~~, she is punished for having opposed it.

I ~~nolonger~~ have the choice as to whether ~~to~~ pay a fine or go to prison my continuous involvement in NVDA has meant that when I now end up court I am ~~no~~ longer given ~~any~~ option; I now face the prospect of longer and longer custodial sentences.

I resolutely believe that there is _no_ difference between women fro the peace movement and women who find themselves in prison for other ~~reasons~~. We may have travelled different routes, but ~~there we are~~ what it boils down to in the end is that we are imprisoned solely because we are women; we are independent and strong and are no longer willing to be treated as second class citizens.

For this the ~~state~~ choose to punish us.

　　　　　　　　　　　　　　　　　　　Lyn Barlow

Lyn Barlow
Greenham Common Journal
1984–89

1984

'I will not be bound over to keep *your* peace: I am already keeping my peace. I will not take punishment, or recant, or admit guilt. I am responsible for this — for seeing the war machine grinding on, building silos, arming the arsenals of the world with death — and using all the non-violent means I can to stop it. *I am asking you to keep the peace. We are not on trial, you are.*'

Katrina, Greenham Peace Camp

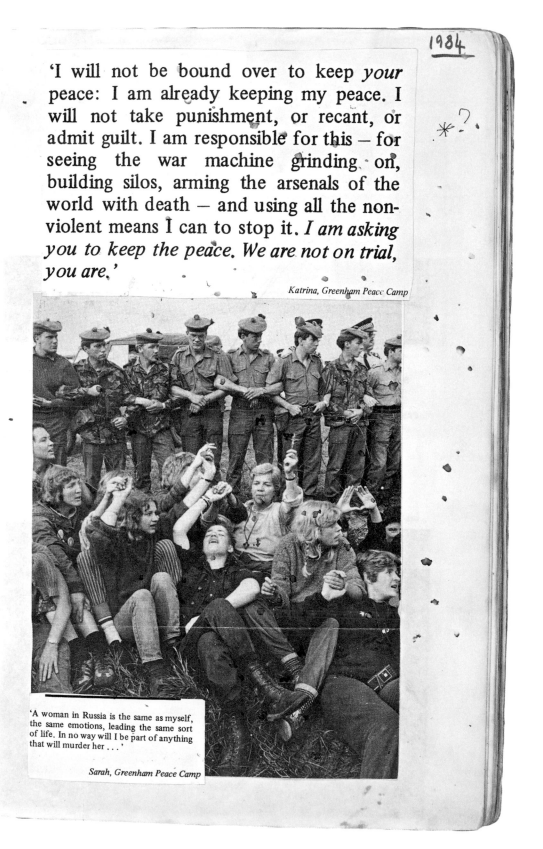

'A woman in Russia is the same as myself, the same emotions, leading the same sort of life. In no way will I be part of anything that will murder her . . .'

Sarah, Greenham Peace Camp

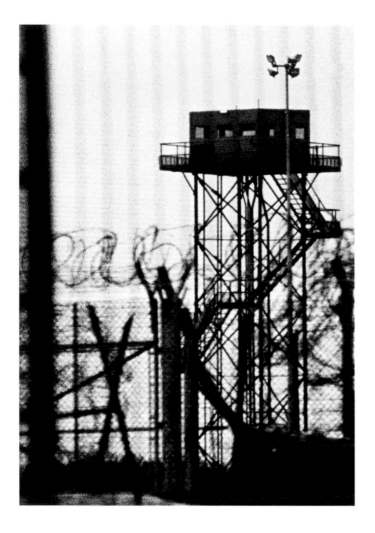

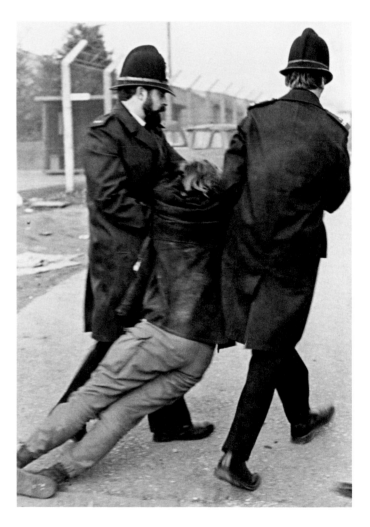

Unknown photographer
Camp, Fence and Bailiffs
c.1987–2000

Brass Brassett
Protester being dragged away by
two police officers
8 March 1983

CRIMINAL DAMAGE ACT

LAWFUL EXCUSE

The special lawful excuses

Sub-s.(2) (b) provides that an honest belief in a right to protect property
or a right or interest in a property, whether one's own or another's, will
afford a lawful excuse for the destruction of or damage to property within
the range of offences to which this section applies. The excuse thus provided
will cover cases where the offender mistakenly believes that he or some other
person has a right which requires protection (thus over-ruling GOTT v. MEASURES
[1948] 1 K.B.234; [1947] 2All E.R.609). The excuse provided under this su-sect-
tion is subject to two conditions: (1) that there be an honest belief in the
immediate necessity of protection; (2) that thre be an honest belief in the
reasonableness of the means used or proposed to be used.

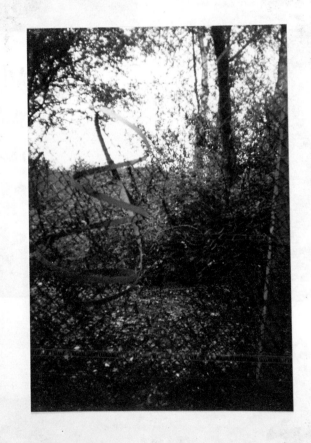

Lyn Barlow
Greenham Common Journal
1984–89

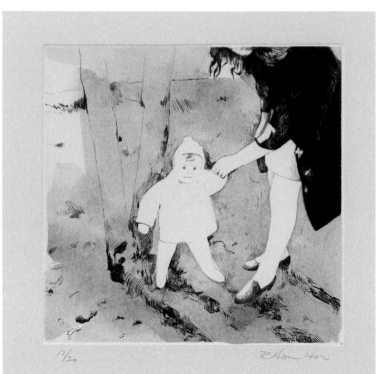

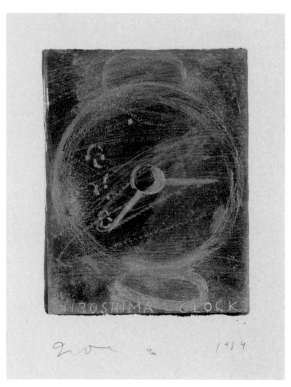

Jim Dine
*Hiroshima Clock, First
Version* from *Greenham
Common* print portfolio
1984

Richard Hamilton
Mother and Child
from *Greenham Common*
print portfolio
1984

Dieter Roth
Untitled from *Greenham
Common* print portfolio
1984

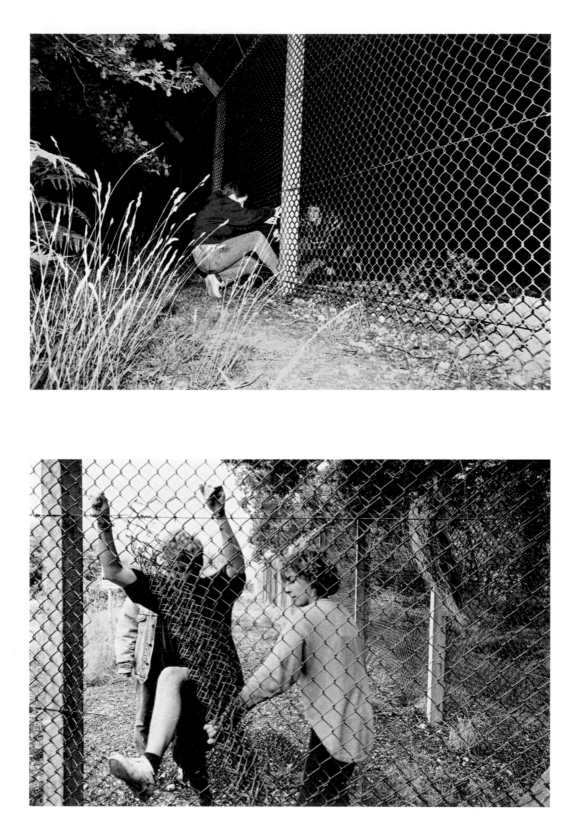

*Lyn Barlow and two
other women breaking
through the fence
at Greenham Common
1980s*

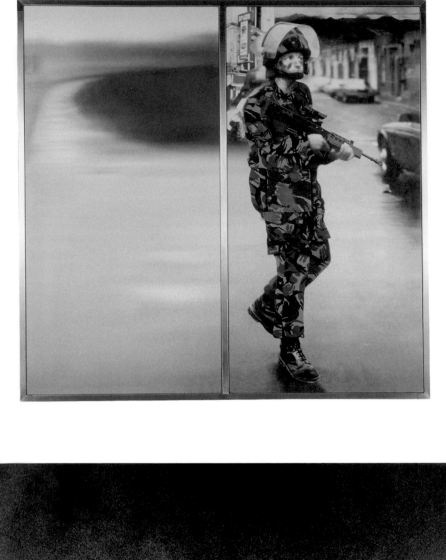

Richard Hamilton Colin Self
The state *Guard Dog on a Missile Base, No. 4*
1993 1966

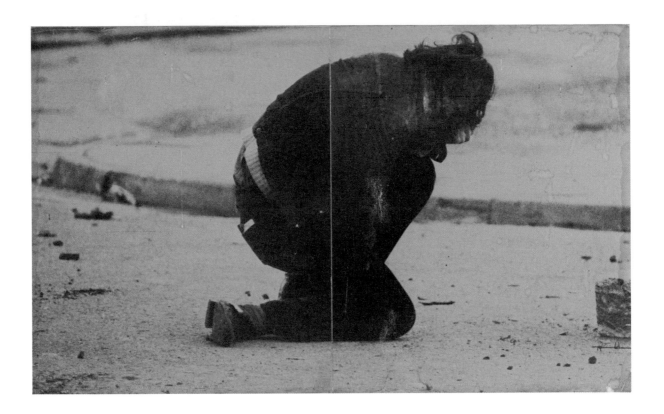

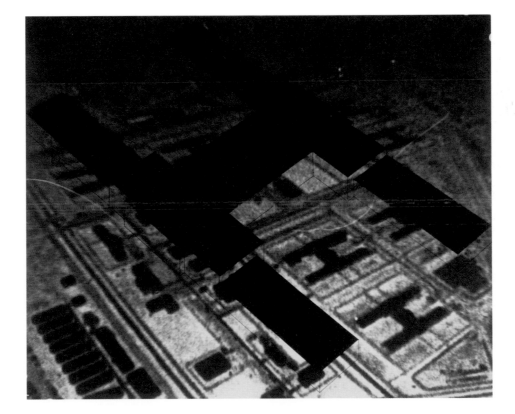

Rita Donagh
Belfast boy
1973

Rita Donagh
Single cell block
1984

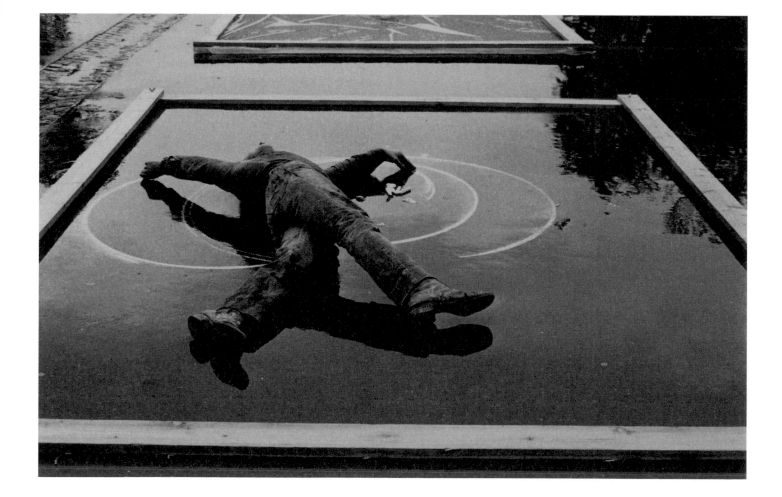

Stuart Brisley
Beneath Dignity
1977

ARTIST PROJECT PETERLEE

2B Yoden Way, Peterlee, Co. Durham. Telephone: 0783-867498.
Funded by the Peterlee Development Corporation and Manpower Service Commission.

2nd Peterlee Report.

Peterlee Report is organised in two parts:

The first part involves a peoples' collective history of the area immediately surrounding Peterlee New Town.

It comprises of a collection of photographic material, most of which has been copied from original photographs people have kindly lent us, and a body of tape recordings and transcripts of conversations which have been made with people who have lived in the local area all their lives.

This material covers personal, domestic, social, sport, work and political activities in the area of Blackhall, Castle Eden, Easington Colliery, Easington Village, Horden and Shotton. There will be a continual exhibition of photographic slide material, supported by live commentary, lectures will be given to school parties and organisations on request. Please phone Sunderland Arts Centre, Sunderland 41214, to arrange lectures.

Two coaches have been arranged to take people from Peterlee and Easington area, who would like to come to the opening at 3.00 p.m. on Monday the 16th, May at Sunderland Arts Centre. If you would like to reserve a seat please contact Artist Project at 2B Yoden Way, Peterlee. Telephone Peterlee 867498.

V.E. or V.J. Party 1945-6, Old 6th Street, Horden.

The second part of the project involving independent contributions is concerned with the history of the development of Peterlee New Town, the Peterlee Development Corporation, the concept behind Artist Project and a history of womens' life in the area.

The project is seen as a means of collecting, collating and presenting a wide spectrum of the views and attitudes of people who live in Peterlee and the immediate surrounding area. It takes the form of a proposal to establish an open community workshop engaged in questions which are relevant in personal and social life. The project itself is scheduled to end in September, 1977, but we hope means will be found for it to be developed within the community.

The project has received a massive support from people living in the area and we hope that you will visit the project in Sunderland to see it in its most complete form. Hopefully not for the last time

ARTIST PROJECT
Peterlee.

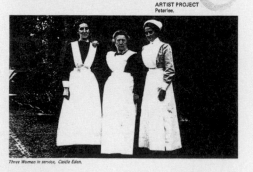

Three Women in service, Castle Eden.

Lecture Series:

Caroline Tisdall — Art Critic of the Guardian and Member of the Free University of the E.E.C.

Fred Robinson — Rowntree Trust: University of Durham

Artist Placement Group — London

Colin Ward — Public Relations Officer, Peterlee Development Corporation.

John Cumming — Easington District Council.

Bill Horsefield — Peterlee Town Council.

A series of discussions and talks involving these people are being arranged. Full details will be announced later.

United Bus Services to Sunderland from Peterlee and Surrounding District

Place	Bus Service
Blackhall	230
Castle Eden	215
Easington Coll.	230
Easington Village	212, 213, 213, 215, 230
Horden	230
Peterlee	212, 213, 214, 215
Shotton	212, 213, 214

Forthcoming exhibitions at Sunderland Arts Centre.

June 27th — July 16th
Rita Donagh, Paintings and Drawings

Rita Donagh's art, with a map — like precision and of a similar linear quality, explores the infinity of space. The exhibition, which will look at her work over the past ten years, traces this exploration. Six phases of work; Taking the Trouble, "Walden", Reflection on 3 weeks in May 1970, New Bearings, Ulster and Newspaper Vendor, are represented in the exhibition, each marked by a key painting. The exhibition has been organised by the Whitworth Art Gallery, Manchester and toured by the Arts Council of Great Britain.

July 15th — August 13th
Jean Cocteau

Drawings, paintings, lithographs, ceramics, tapestries, sculptures, illustrated books, and documents evoking Jean Cocteau and all his diverse talents as a novelist, playwright, film-maker and painter.

Sunderland Arts Centre is currently financed by Sunderland Borough, Northern Arts and the Arts Council of Great Britain.

Artist Project Peterlee
Second Peterlee Report
c.1973–78

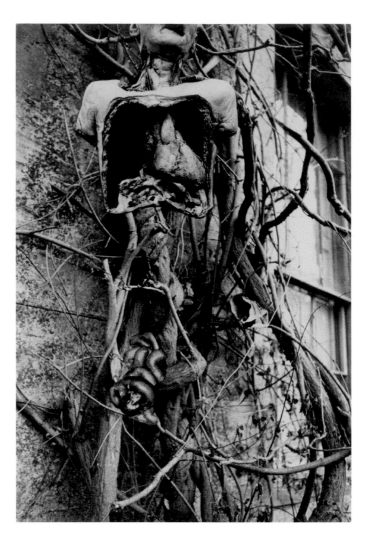

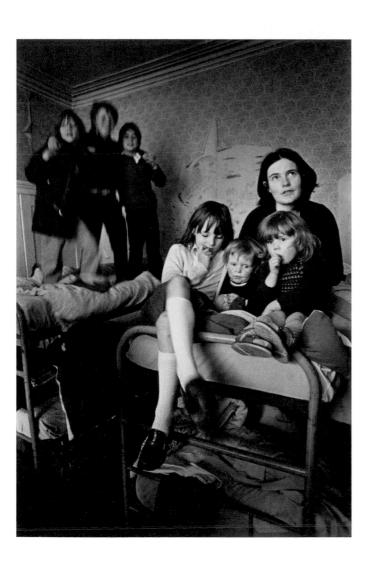

Christine Voge
Untitled (Three children and woman)
1978

Penelope Slinger
Corpus
1977

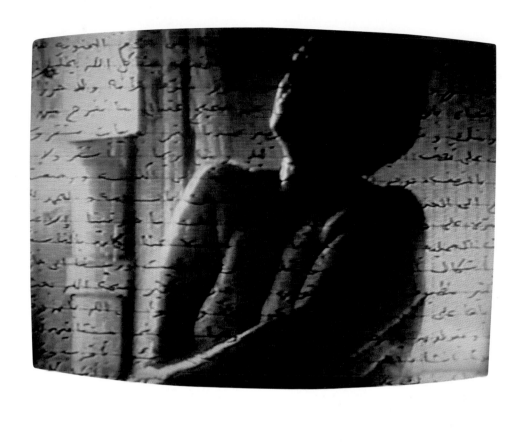

Mona Hatoum
Measures of Distance
1988

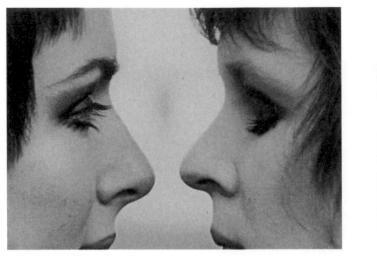

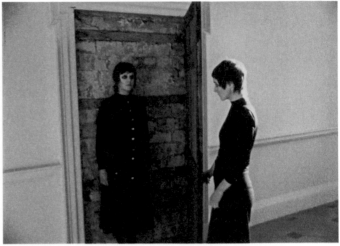

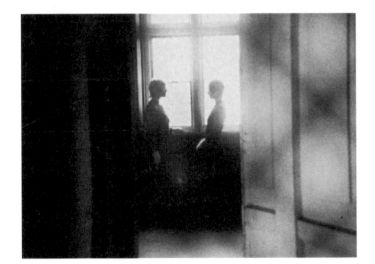

Penelope Slinger
Lilford Hall
1969

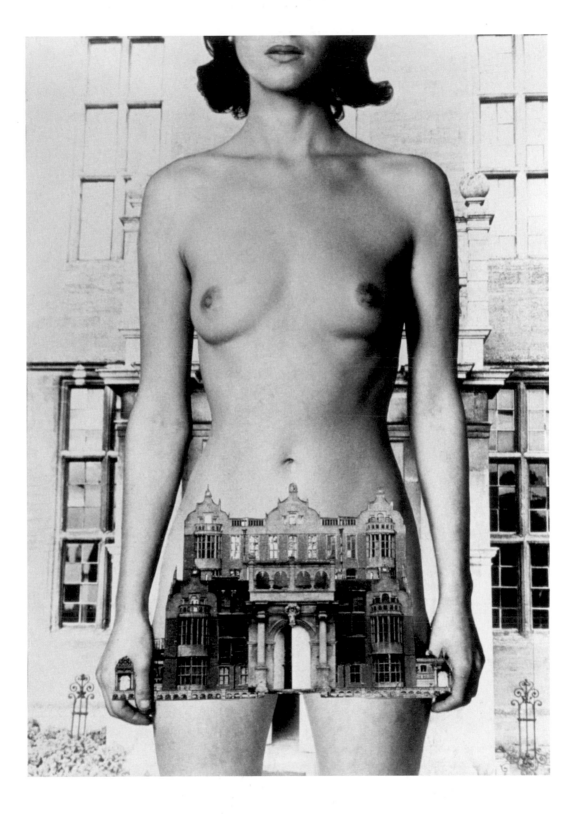

Penelope Slinger
Perspective
1977

Toby Paterson
Rotterdam Relief
2005

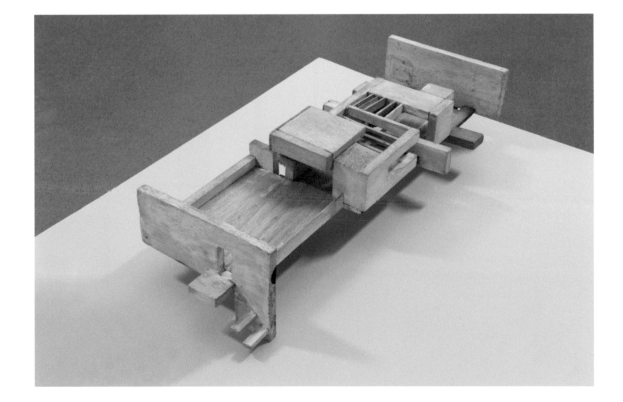

Jane and Louise Wilson
Apollo Pavilion, Peterlee
2003

Victor Pasmore
Model for Apollo Pavilion, Peterlee
c.1967

Victor Pasmore
What is the Object over There?
Points of Contact No. 17
1973

Victor Pasmore
Construction in Black, White and Ochre
1961

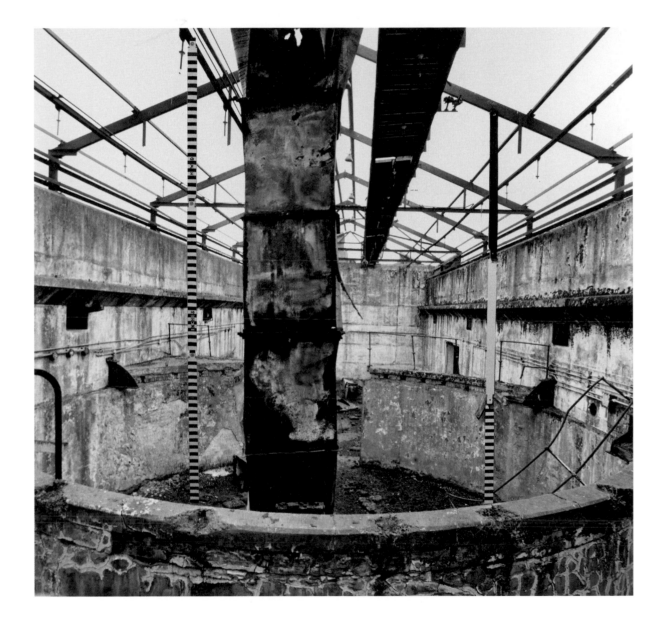

Jane and Louise Wilson
'Blind Landing' Lab 4
2012
Installation view, Orford Ness, 2012

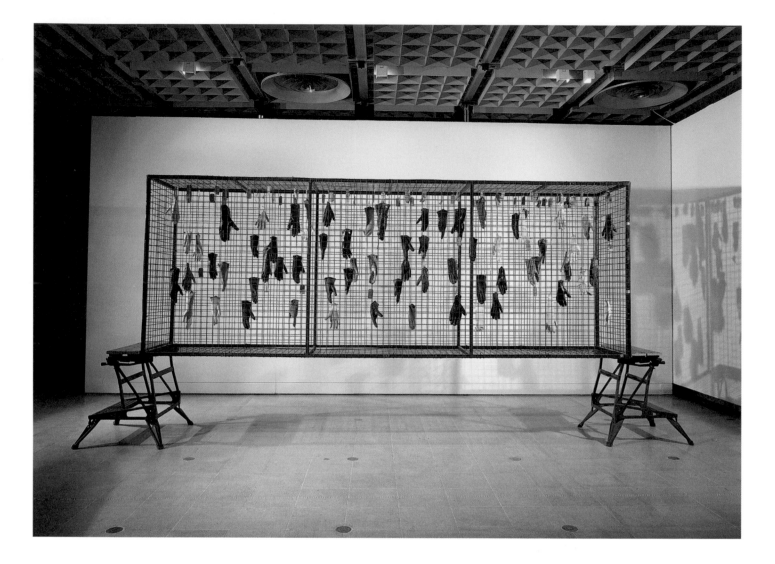

Stuart Brisley
1=66,666 (March 1983 – Georgiana Collection VI)
1983

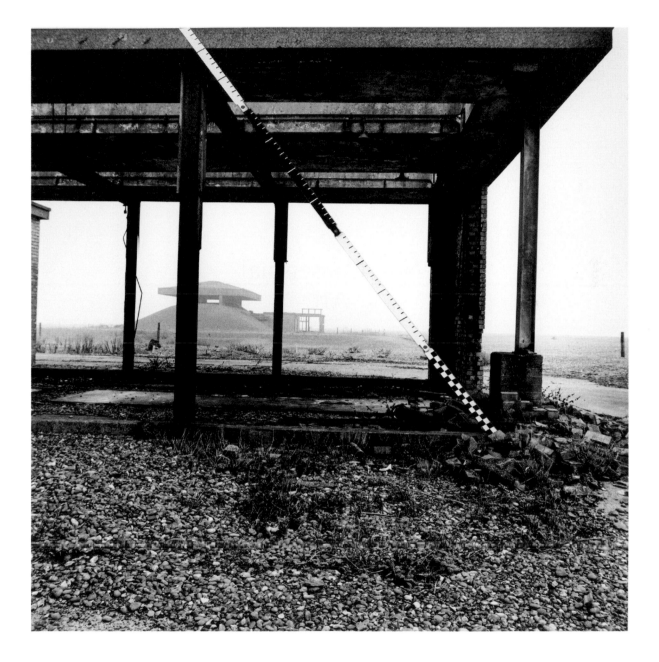

Jane and Louise Wilson
'Blind Landing' Lab 1
2012
Installation view, Orford Ness, 2012

Non-Consensual Art

'As a practice charged not just with creating the infrastructure
of the welfare state, architecture was also,
and just as importantly, given responsibility for creating
signs of ever-accelerating progress.'

Sometime in 1972 at the Goethe Institute in South Kensington I remember entering a room where a bath of stagnant, slimy water was filled with putrefying organic matter – and the living body of Stuart Brisley. I got out quickly. The stench was unbearable, and it seemed an intrusion on a private confrontation between the artist and his nemesis. Whatever was going on, it did not need a spectator. In that moment, though, something changed, and the relatively polite art of post-war Britain, with which I had been familiar, slipped its hold. Francis Bacon had been as nasty as it got. Here was something that seemed to rip away at the insides of art, to be followed in the years to come by art that tore away at the insides of society.

In the previous 25 years art had been not only polite but, more significantly, *consensual*. It spoke to everyone, and aspired to represent all classes and interests. Even when it was critical, there was an assumption that it would draw people together, rather than drive them apart or question the bonds between them. By the early 1970s, all that was changing.

Victor Pasmore's Apollo Pavilion in the new town of Peterlee in County Durham belongs to the consensual tradition, though it was produced towards the end of that tradition's heyday, and by the time it was finished was already an anachronism – a fact that possibly contributed to its subsequent vandalism and neglect. The Pavilion, a large concrete eye-catcher surrounded by housing, was intended, Pasmore later explained, to make it clear that Peterlee was not just

'Ever since Courbet exhibited *A Burial at Ornans* in 1850, artists have been using art to lay bare social divisions, but in post-war Britain this particular function of art was put into abeyance.'

an overblown housing estate, but an important town. Its purpose was to endow this part of Peterlee with civic qualities. Pasmore described the Apollo Pavilion as 'a free and anonymous monument, which, because of its independence, can lift the activity and psychology of an urban housing community onto a universal plane'; it was 'to embrace the whole process of the human psyche'. Pasmore believed in the redemptive power of art, its capacity to reveal a higher order of being not visible in the humdrum of everyday life and its ability to unite humanity. His statements, with their faith in art's ability to transcend the immediate social reality, are utopian – and were no longer the sort of pronouncements that artists were inclined to make even as Pasmore was finishing his monument.

Ever since Courbet exhibited *A Burial at Ornans* in 1850, artists have been using art to lay bare social divisions, but in post-war Britain this particular function of art was put into abeyance. For 25 years, while there was realism, the notion that art spoke a common language that drew humanity together was never in doubt. The reasons for the suspension of avant-garde art's critical function had to do with the post-war settlement that in all Western European countries had created a consensus between capital and labour. Universal access to a range of social benefits – health, education, unemployment relief – and progressive taxation with some redistribution of wealth and a narrowing of differences in income, created conditions of relative social stability. For the most part

Roy Bolsover
Drawings for Victor Pasmore's South West 5 Pavilion, Peterlee (unbuilt)
1968–69

'The Aylesbury and the neighbouring Heygate Estates in Camberwell, South London, built between 1967 and 1976 together constituted the largest local authority housing scheme in Britain, and featured the longest slab block – now demolished – built anywhere with an industrialised building system.'

artists, and the institutions of art and culture, were willing collaborators in this shared social vision. However, the welfare state was not without its contradictions. Consensual acceptance of the arrangements rested not so much upon the actual services and benefits available in the present, but upon future expectations of the rising standard of living and social levelling that they would bring about – upon what the contemporary social theorist and ideologue of the welfare state T.H. Marshall called 'the superstructure of legitimate expectations'. But there was a trap here: as Marshall put it, 'as the standard of the service rises – as it inevitably must in a progressive society – the obligations automatically get heavier. The target is perpetually moving forward, and the State may never be able to get quite within range of it'. Fundamental to the welfare state project was a structural and unclosable gap, between the lived conditions of the present, and 'the superstructure of legitimate expectations'. Much British post-war art operated within the space created by this superstructure, most obviously cinema, with films like *Room at the Top* (1959) or *Saturday*

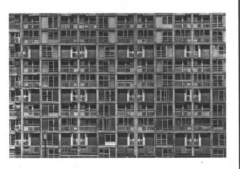
Park Hill Estate

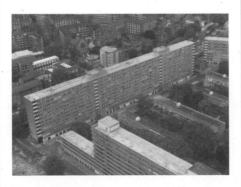
Heygate Estate

Night and Sunday Morning (1960), but so too visual art – Richard Hamilton's works from the 1950s and early 1960s made much of the imagery that fed those expectations.

If post-war art was heavily consensual, even more so was architecture. As a practice charged not just with creating the infrastructure of the welfare state – schools, housing, hospitals – architecture was also, and just as importantly, given responsibility for displaying signs of ever-accelerating progress, a scenery of change that would create the impression that those ever-rising expectations might possibly be satisfied, if not today, then soon. The fixation of both the state and of the architectural profession with non-traditional methods of building in the post-war era was partly on account of the visible proof that these systems sped up construction. The choice of precast concrete panels for all those new housing blocks was not an *economic* necessity – they were not the cheapest way to build – instead speed became an ideological necessity. Sometimes the results were quaint: the decidedly massive and non-traditional form of the Park Hill Estate in Sheffield, conceived at a time when rockets and space travel were on the technological horizon, was partially arrived at so as to accommodate the dimensions of that most traditional, slow-moving, and peculiarly British piece of socio-technical apparatus, the milk float. And sometimes the results were awe-inspiring. The Aylesbury and the neighbouring Heygate Estates in Camberwell, South London, built between 1967 and 1976 together constituted the largest local authority housing scheme in Britain, and featured the longest slab block – now demolished – built anywhere with an industrialised building system. Rather than think of all the system-built housing in Britain as so many individual works, we would do better to think of them as one giant work, the creation not of individual architects and contractors, but of one single political-ideological system dedicated to turning the urban landscape of Britain into a scene of ever-accelerating progress.

Many of those blocks of housing have since been demolished as part of the process of what is misleadingly called 'urban regeneration' – a metaphor that implies some kind of organic self-repair, when in fact what has been

Mark Lewis
Children's Games, Heygate Estate
2002

'The choice of precast concrete panels for all those new housing blocks was not an economic necessity – they were not the cheapest way to build – instead speed became an ideological necessity.'

happening has been the return of land that had in economic terms been 'frozen' back to the market, so releasing its capacity to generate profit. Compared to what often replaces them, the original housing doesn't seem that bad; at least the space standards were more generous than those of the new buildings, and there was a vision of collective life absent from their replacements. Even if their surroundings often manifested a dismal emptiness, an unfortunate result of the urban decongestion policies that politicians and planners pursued so energetically in the post-war period, the best of them imagined a world made up not just of individuals, but embodying a shared, collective life. Recent reappraisal and campaigns to protect some of these buildings have drawn attention to values once held, but now largely forgotten.

David Hepher's paintings and Mark Lewis's films of the Heygate and Aylesbury Estates might easily be mistaken as belonging to this current critique of the neo-liberal developments that are taking their place. But in reality, both Hepher's and Lewis's works are totally neutral, and simply *look* without making any judgement, positive or negative. Hepher's painting concentrates on a single view, Lewis's *Children's Games* (2002) traverses the elevated walkway of the Heygate estate at a constant fast walking speed; the effect in both cases is to create an eerie stasis, removing both from time. Inadvertently, this static effect draws attention to that long lost aspect of their original purpose: to furnish a scenery of rapid and continuing change.

Architecture, so heavily implicated in the politics of consensus, was a late-comer in the unravelling of the welfare state that began in the late 1960s, and architects for a long time remained perplexed by the changes, at a loss to know how to act. Artists, on the other hand, had been much quicker to see the chimerical nature of the entire post-war settlement, and to start to question both it and the nature of art's complicity in it. Artists like Richard Hamilton, Stuart Brisley and Conrad Atkinson began to make art that was increasingly concerned with sites of confrontation. Whether those sites were in the home, as in Alexis Hunter's scenes of domestic violence, in Northern Ireland, as in Hamilton's 'Protest' paintings, or geopolitical, like his *Greenham Common*

'Artists, on the other hand, had been much quicker to see the chimerical nature of the entire post-war settlement, and to start to question both it and the nature of art's complicity in it.'

print portfolio, 'politically engaged' art no longer meant art that represented the interests of humanity as a whole, but rather work that picked apart art's relationship to consensual politics.

What finally closed the door on consensual art, however, was when the state itself turned upon its own citizens: in Margaret Thatcher's infamous speech to the Conservative Backbenchers in 1983, she announced that having defeated 'the enemy without' – Argentina – the government would fight 'the enemy within' – the miners' leaders – who were 'just as dangerous to liberty'. No previous post-war government had dared to speak like this, had contemplated implying that it acted for anything other than the interests of all. Once Thatcher had made her speech, consensual government was over, and in future politicians who claimed to speak for a consensus would struggle to make themselves credible. In these circumstances, consensual art ceased to make sense.

Yet the issues that the public art of the 1960s tried to address have not entirely gone away. Issues about 'the common interest', what it is and how it might be represented, still remain and indeed underlie many of today's cultural and political concerns. To take one example, planning the new town of Ebbsfleet in Kent has raised exactly the same kind of questions that Pasmore faced in Peterlee, of how to make a town out of what is in effect a gigantic housing estate. Maybe such issues are not the business of art, but they are still nevertheless someone's business. Can the interests of the collective be articulated, and, if so, by what means?

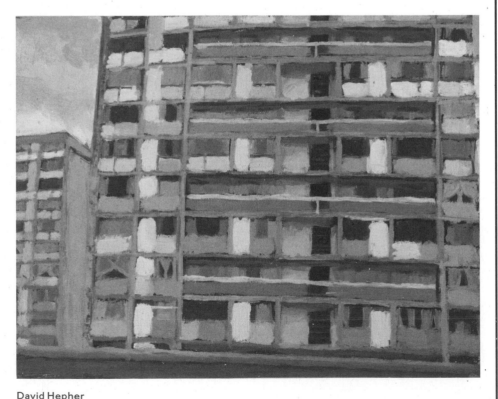

David Hepher
Study for 'Arrangement in Turquoise and Cream'
1981

John Akomfrah

'Part of the Collection is about the emergence
of artist filmmakers who were not using film to express
exterior reality, but are themselves the artworks.'

Many of the films that I have selected from the Arts Council Film Collection can be seen as sites of convergence. The most successful ones are those where the meeting of different art forms has a transformative impact on all of the different elements involved. When the Ballet Rambert, for example, decided that they wanted to make *Imprint* (1974) you could see that they were considering, very seriously, the things that film offers to dance; the ability to montage, for example, or to cut – sometimes very disturbingly – between scenes. The result is not merely a filmed dance piece, but a 'pro-filmic event'. It could only ever have taken place as a film.

It is difficult to imagine the existence of some of the films in the Arts Council Film Collection without the profound cultural transformation that began in this country with the free cinema movement of the 1950s. Intellectual transformations were brought about by texts such as Richard Hoggart's *The Uses of Literacy* (1957) or Raymond Williams' *Culture and Society* (1958). In Alnoor Dewshi's film *Latifah and Himli's Nomadic Uncle* (1992) one can see traces of theorist Edward Said's *Orientalism* (1978), as well as the theoretical essays of postcolonialist scholar Homi K. Bhabha. Films such as these don't merely reflect their cultural origins, however. Instead they act as prisms that refract their influences and cultural and historic contexts in myriad, complex ways.

While the Arts Council Film Collection contains a diverse array of approaches, genres and subject matter, there is a degree of continuity. Some of this is down to personnel: many of the films share directors, or were produced by the same company. Margaret Williams was a director who was involved with Arts Council productions for decades. You can often feel her influence even when she's not directing. In the dance piece *Pace* (1995), for example, you can feel her in the background licensing the spirit of abandon and freedom in the work; enabling and cajoling something remarkable out of people who were just beginning their own journey.

Something that is a marker of formal success in these films is whether it has been able to outlive its subject matter, or particular historic moment. A good example of one that has is *Winston Silcott. The beard of justice* (1994), directed by Rodreguez King-Dorset. In 1985 there were a series of riots across London, and in Tottenham a police officer, PC Keith Blakelock, was killed. Thirteen men were arrested, and three men – Winston Silcott, Mark Braithwaite and Engin Raghip – were imprisoned in 1987. Eventually, it emerged that these men were innocent; they were released in 1991. You don't need to know the background to this film to understand it. It works, even now, as a powerful portrait of incarceration and wrongful imprisonment.

Some of the works in the Collection are overwhelmingly prophetic. One such film is *A Sign is a Fine Investment* (1983) by writer Judith Williamson, who was known at the time for publishing a well-regarded book on advertising called *Decoding Adverts* (1978). I think a lot of what Williamson had to say in her film is now even more important than it was when it was made. Advertising is one of those areas of our life that, post-1945, has grown exponentially. The fact that Williamson was, in the 1980s, trying to sketch the outline of a zeitgeist made it an important film to have in the show.

In general I have selected works that have an intimacy with filmmaking as well as the art form that they are concerned with. It was also important for me that each film had some sort of signature; that it appeared to be made by someone who had a clear set of formal concerns to unpack. Part of the Collection is about the emergence of artist filmmakers who were not using film to express exterior reality – or a specific art form such as sculpture, painting or dance – but are themselves the artworks. Malcolm Le Grice's *Whitchurch Down (duration)* (1971) is one of these: it is wholly its own thing.

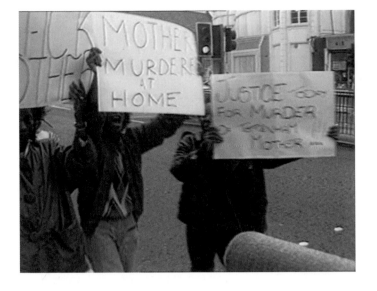

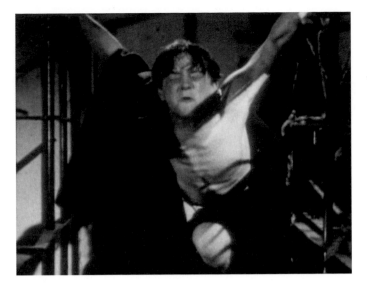

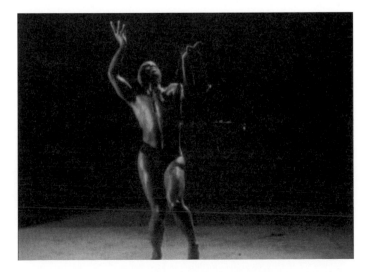

Rodreguez King-Dorset (dir.)
Winston Silcott. The beard of justice
1994

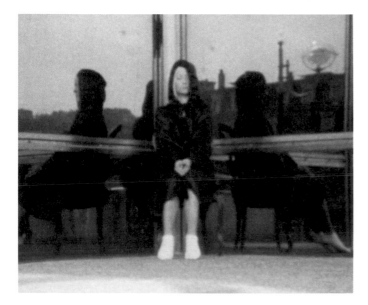

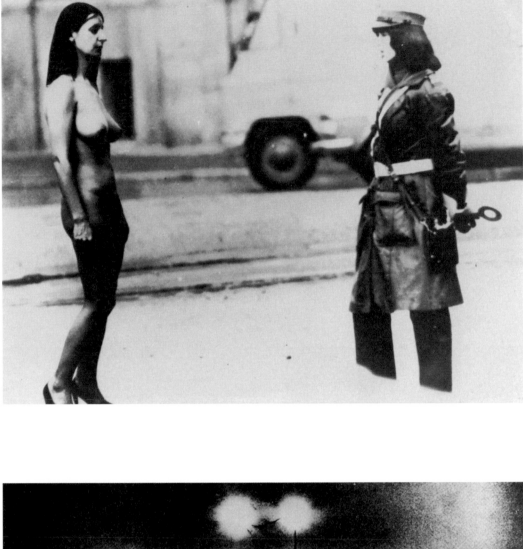

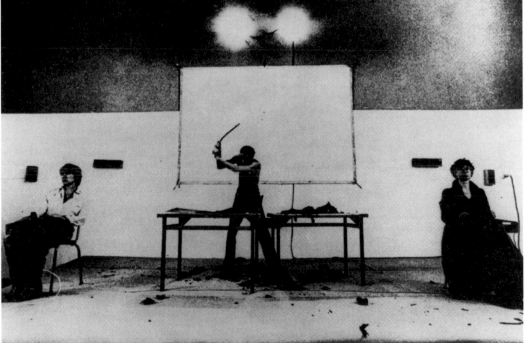

Stuart Brisley and Ken McMullen (dirs.)
Being & Doing
1984

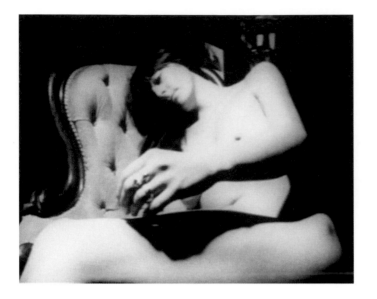

Steve Dwoskin (dir.)
Shadows from Light.
The Photography of Bill Brandt
1983

The Lacey Family (dirs.)
The Lacey Rituals. Some of the rituals,
obsessions & habits of the Lacey Family
1973

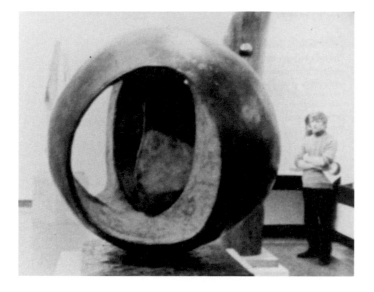
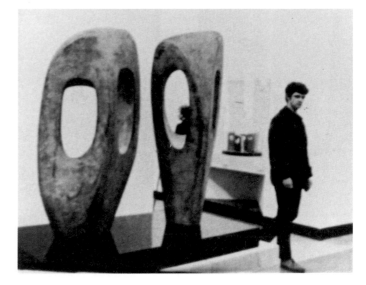

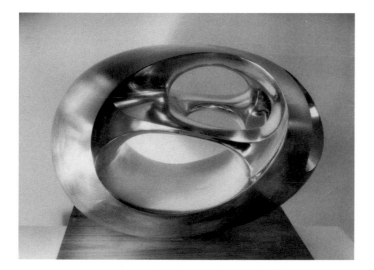

Bruce Beresford (dir.)
Barbara Hepworth at the Tate. Filmed during the Barbara Hepworth retrospective exhibition at the Tate Gallery, London, 3rd April 1968–19th May 1968
1968

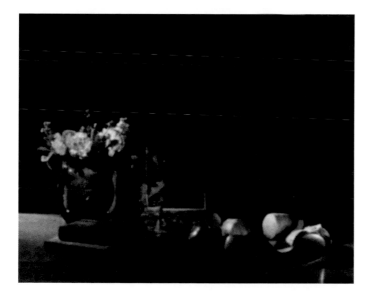

Gilbert & George
The World of Gilbert and George
1981

Peter Wyeth (dir.)
12 Views of Kensal House
1984

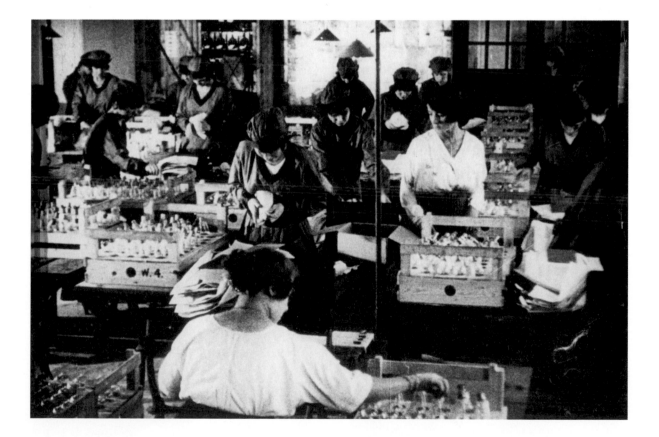

Judith Williamson (dir.)
A Sign is a Fine Investment
1983

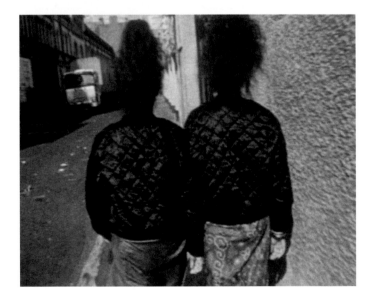

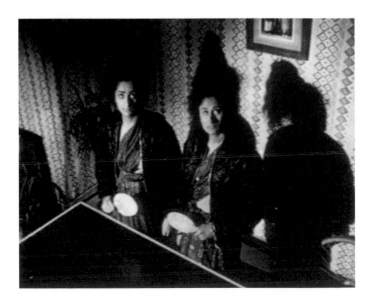

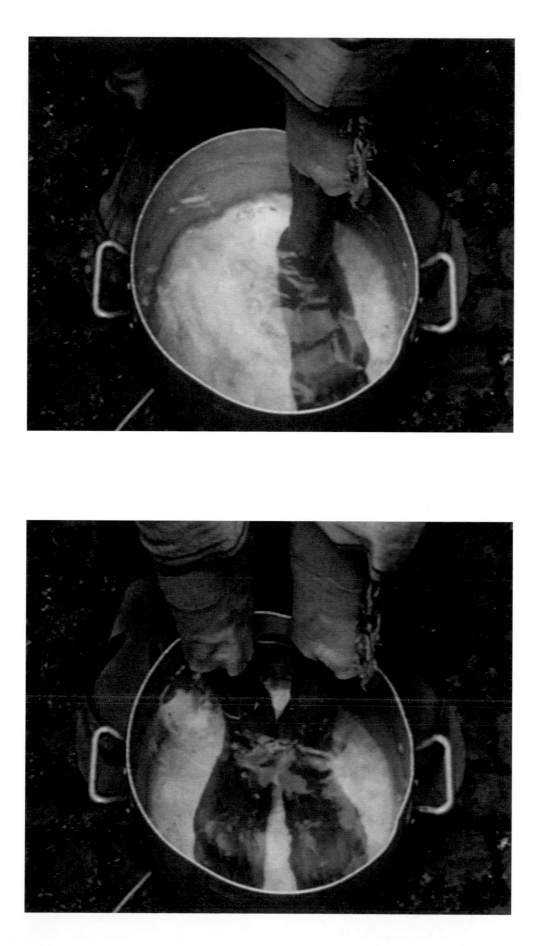

Alnoor Dewshi (dir.)
Latifah and Himli's Nomadic Uncle
1992

Margaret Williams (dir.)
Jeff Keen Films
1983

James Scott (dir.)
Richard Hamilton
1969

Nicholas Monro (dir.)
Sailing Through
1971

Malcolm Le Grice (dir.)
Whitchurch Down (duration)
1971

Single Moments,
Present Tenses

1948

There is no such thing as a single history
is what they're telling me about today.
My memory is hazy as the sea spray that day
when I come off the Ship that makes history
and arrives to find *No* written on the doors
of mute houses and zero good job opportunities.
And the milk not flowing, nor the honey, either.
But here, now, looking back on us:
What a contribution we made to the nation!
You know what I'm saying, **uh huh** and that day
The wind rushed and the flowers bloomed,
that day in June, and would have been blooming
even in deep midwinter, I imagine – glorious heads.
And I felt myself part of a throng, a people;
I went from a single woman to many
In the time it takes to walk down a step, to skip
along the deck, and off the ship: step, step, step.
It is not I who arrives. It is *We*. Good shoes on,
holding my hat on my head, suitcase in my hand,
my face, caught here, in black and white,
my brown face, obscured a little by the sea mist
like the fog hid the land that first winter,
waiting for myself maybe to catch up with time:
or – likely – for time to catch up with me.

1958

There comes a moment in time
When you have to *do* something.
When it comes you are ready for
The moment coming. You are poised,
History is fluid in the making.
You can't catch it flying past: Greyhound moments.
And yet time is underscored; and, as your name enters
The history books, you say, you mean:
This is not about me. This is not about me.
But still, there you are, the founder of CND
And when you march then from Aldermaston
Singing *Brother won't you join the line?*
You hear your own voice becoming stronger.
You say *we are many,* you say, yes
The world is full of magical things patiently
Waiting for our wits to grow sharper.
You say *War does not determine who is right*
Only who is left and you hear the many-voiced crowd cheer.
This is your time. You wear the Holtom sign. Here we are.
Here you are – a Goya figure. Landed on earth as if on the moon.
You have marched against Polaris. You have sat down at Dunoon.
You are singing the songs with your friends of the loch.
Och, och get oot the holy loch, get oot the holy loch.

1968

And one day you find yourself in floods
when you realise that Dr Martin Luther King Junior
who said *I'd like for somebody to say yes*
I was a drum major for peace, had a sense
of his end coming before it came,
his clock stopping before it stopped.
And you find yourself weeping for this stranger,
your brother from the United States of America,
whose face you could trace, whose voice
you would know if it came from behind your living room door,
whose noble forehead you could mop.
And you find yourself getting up from your sofa
In your terraced house, in your council flat, in your Wimpey,
slowly, as if you've been dealt a body blow.
You find yourself saying over and over again
I had a dream that one day, I have a dream today
Until your voice cracks when you get to *free at last*
Dr Martin Luther King has been shot dead.
You take some comfort from global mourning.
You will always remember where you were, on this day
As you remember where you were the day they shot JFK.
In your small street, one candle is lit and then another.
At night you leave your amber curtains wide open.
And you think of his heart, his chamber.

1978

From a distance you watch yourself walking into the frame.
At first, you are blurred, as if emerging from the rain.
You feel as if you are being followed along the main road.
Your heart beats like the rain on the roof of your childhood.
You have said the words; you have named yourself out loud.
You have said to your mother a phrase in the conditional.
You have said *how would you feel if I told you I was a lesbian?*
It is yours now the word to claim, though the word is strange,
and drops a picture into your mind that is not you.
And your mother has answered in the same tense: *I would,*
she has said, *I would be upset* but it doesn't matter because you could
you would, you have, walked out of the dark, moonlit night
into the fragile light of day. You are sixteen. You don your dungarees.
Tie the thick laces of your Doc Martens. You pin on a badge
Which reads, *It's a lesbian,* and walk away into the distance
Of years: until the moment comes around again,
And your eighty-year-old mother finds herself saying
Back then, I didn't know what to do or say,
And the day has been, gone, is coming back. The day turned.
Now, if you wanted you could marry under the same sun.
You could have your father walk you down the aisle.
From invisible to visible; a long, long way
from the Gateways days, the *sing if you're glad to be gay* days.
You've ditched the dungarees. 360 degrees.
There is no such thing as a single history.
You say, *Yes*, we are many, you say.
You will always remember where you were on this day.

Hannah Starkey

'I hope to remind people about the pleasure to be
found in intelligent photography, and the
ability of a well-crafted image to shape and inform
our ideas about ourselves.'

In the 1970s and 1980s the Arts Council Collection was one of the few ways for photographers who weren't working commercially to gain funding and recognition. Consequently, the Collection held a pivotal position in the development of British photography. My selection for this exhibition reflects these developments: broadly speaking, early works from the 1970s take the form of small black-and-white prints; in the 1980s the subjects become gradually more political; in the 1990s, the greatest shift occurs: photography is suddenly much larger and less figurative.

The process of selection was a joy for me. As I sifted through the many hundreds of pictures, I found many familiar images that had been introduced to me during my studies of photography: Chris Killip's *Youth, Jarrow* (1976), for example, was the very first image I was shown on my BA course in the 1990s. I have, for a long time, been interested in how you can distil the power of a documentary photograph such as this, and introduce it into a different kind of image. For many years I have also been interested in how visual culture reflects or dictates our ideas about gender: although it was not the intended subject, I find Killip's highly charged photograph emblematic of the frustration and entrapment that culturally determined ideas of gender can cause.

The images that I selected from the Collection were ones that I had a direct and immediate response to, such as Christine Voge's *Crying Child* (1978). My selection was also made with both the male and female figure in mind. This presented me with the opportunity to investigate the ways in which gender has been represented in our visual culture – particularly over these three decades. It also enabled me to compare documentary photography with advertising, and to consider the ways that both documentary photography and advertising can shape or dictate personal and societal opinions. The results have been revealing.

I believe that there is a generation of young women who have been told by advertising that they are little more than sexual objects. These young women, and young men, are being robbed of any enjoyment in the visual. By placing works from the Arts Council Collection side-by-side with images of advertising from the same period I hope to remind people about the pleasure to be found in intelligent photography, and the ability of a well-crafted image to shape and inform our ideas about ourselves. I believe the images from the Collection have a beauty, strength and integrity that is missing from much of our visual culture. As someone who has worked across the board – in advertising, documentary and fine art – I have no interest in the lines between so-called 'high culture' and 'low culture', but what shocks me is the fact that we have a powerful tool of communication that we're using in such a negative way: adverts are often little more than a form of corporate grooming.

The process of selecting images from such an extensive collection brought to mind the work of John Berger, particularly his groundbreaking book and TV series *Ways of Seeing* (1972). Berger's work had a profound influence on me, as I believe it did on an entire generation of visual artists, photographers and theorists. It is useful, in 2015, to reappraise what Berger had to say about visual culture, and reapply it to the images that surround us. I hope my selection of photographs will encourage people to engage critically with the images that make up our culture, just as Berger's *Ways of Seeing* did in the 1970s.

Photography is something that we're closer to than any other kind of art form. It is a universal language that we all have a vested interest in: we need to reclaim it and restore its visual intelligence.

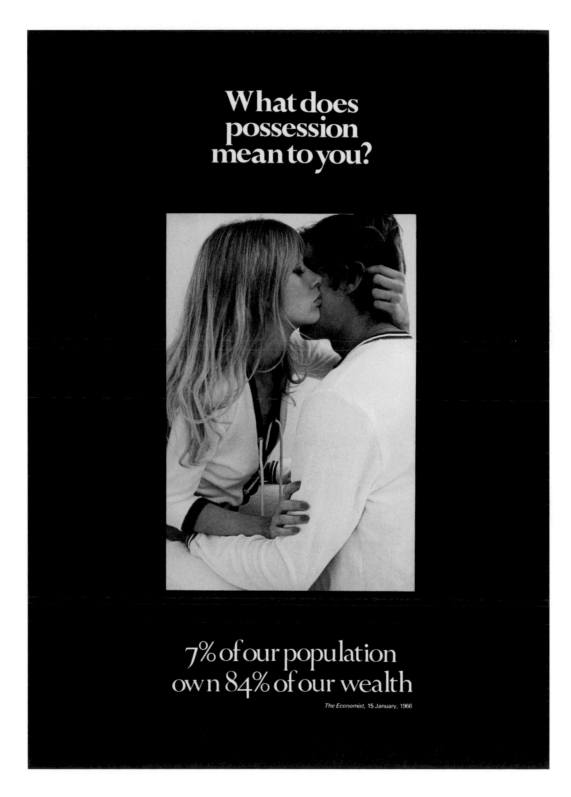

Victor Burgin
Possession
1976

David Chadwick
A Woman on a Hulme Walkway, Manchester
1976

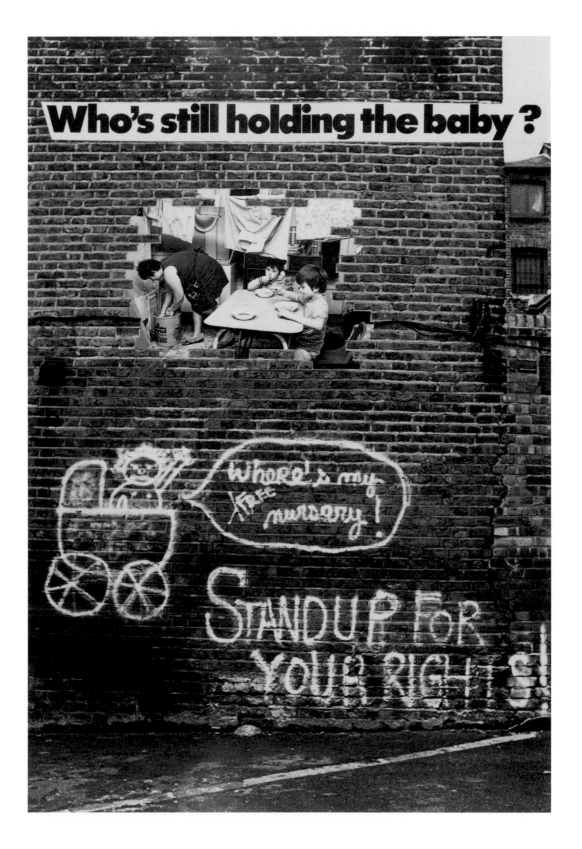

The Hackney Flashers
Who's Holding the Baby?
1987

Hipgnosis
Winkies
1975

Hipgnosis
Untitled
1976

Donald Jackson
Twisted trees, Via Gellia, Derbyshire
1977

Chris Killip
Youth, Jarrow
1976

Melanie Manchot
Mrs Manchot, Arms Overhead
1996

Hayley Newman
You Blew My Mind
1998

John Hilliard
Cause of Death
1974

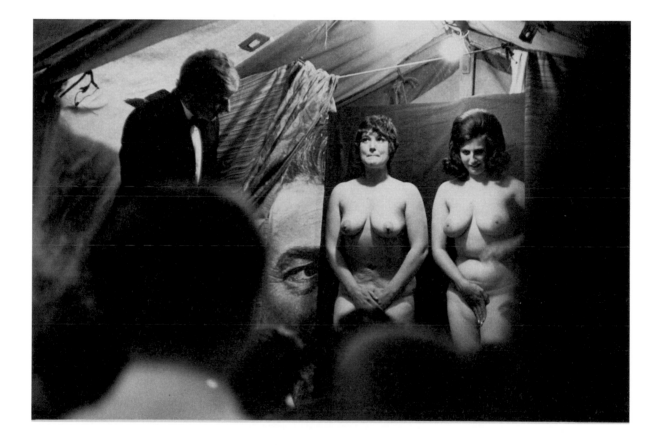

Homer Sykes
Whit Wednesday Pinner Fair, Pinner, Middlesex
1969–75

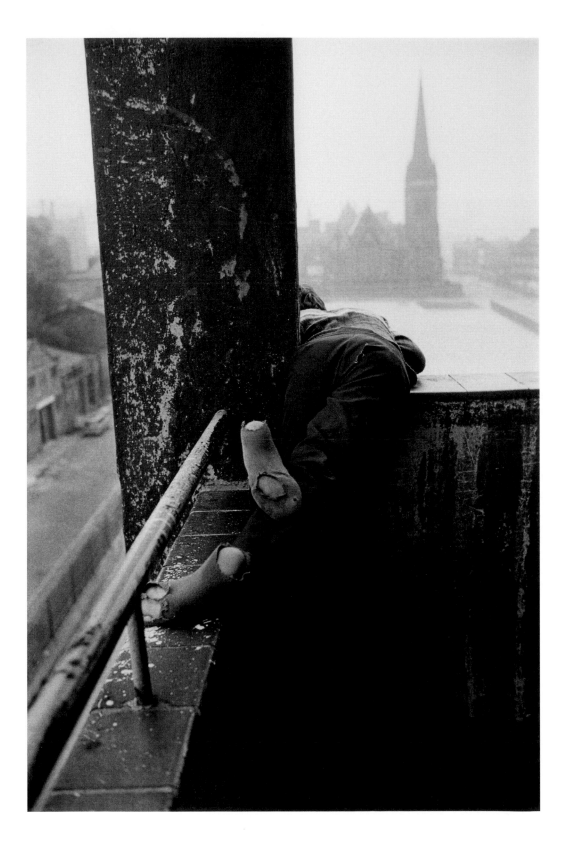

Paul Trevor
Haigh Heights, Haigh Street, Everton, Liverpool
1975

Christine Voge
Crying Child
1978

Jack Yates
Girl Undressing
1972

Sue Packer
Brian Young
(from 'Tintern Portraits', series of 51 portraits)
1983

Sue Packer
Sarah Horton
(from 'Tintern Portraits', series of 51 portraits)
1984

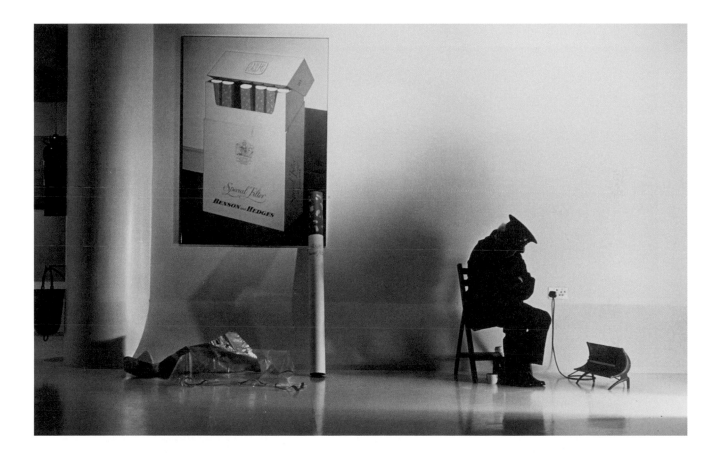

David Montgomery
Untitled (Gallery)
1976

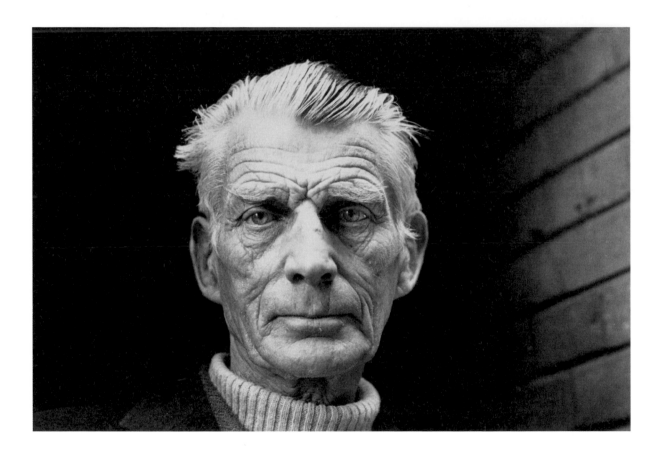

Jane Bown
Samuel Beckett
1976

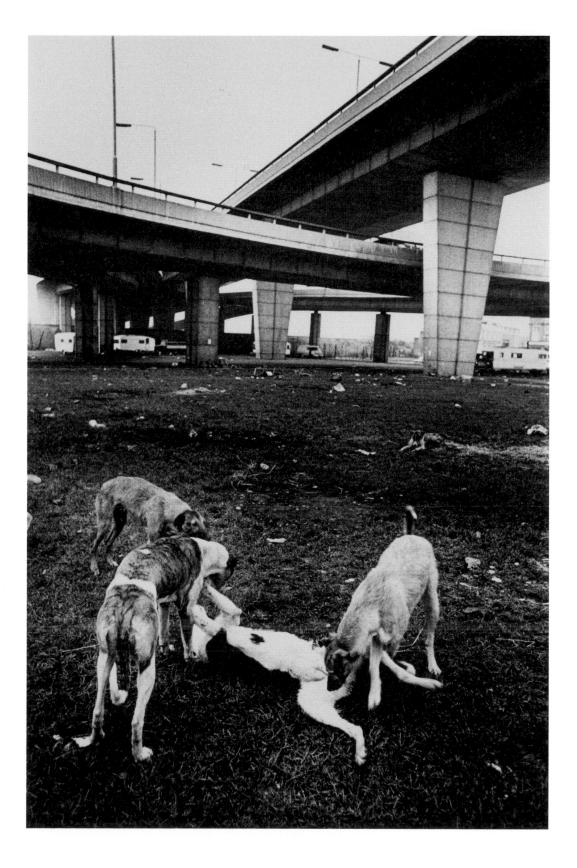

Ian Dobbie
Dogs on Wasteland
1972

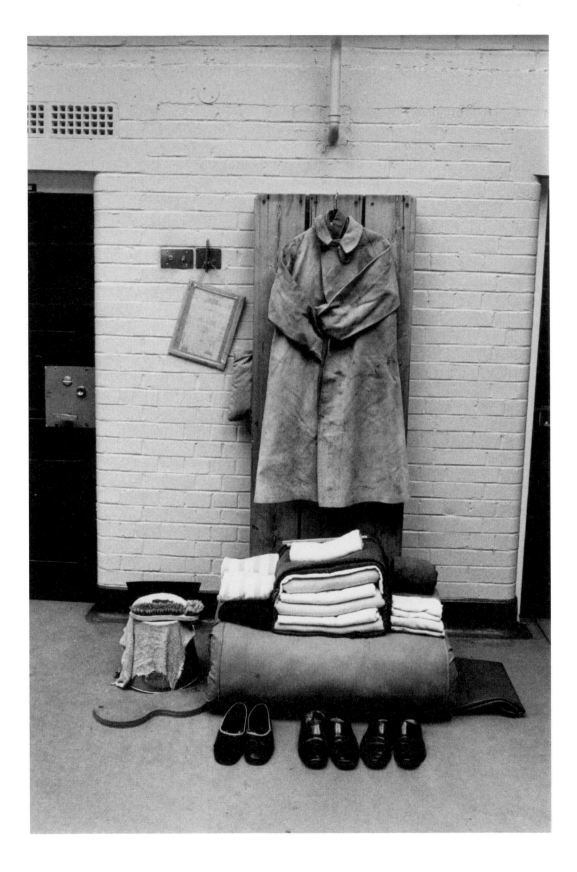

Jonathan Bayer
*Untitled (Gear for cell in punishment block,
Everthorpe Borstal)*
1977

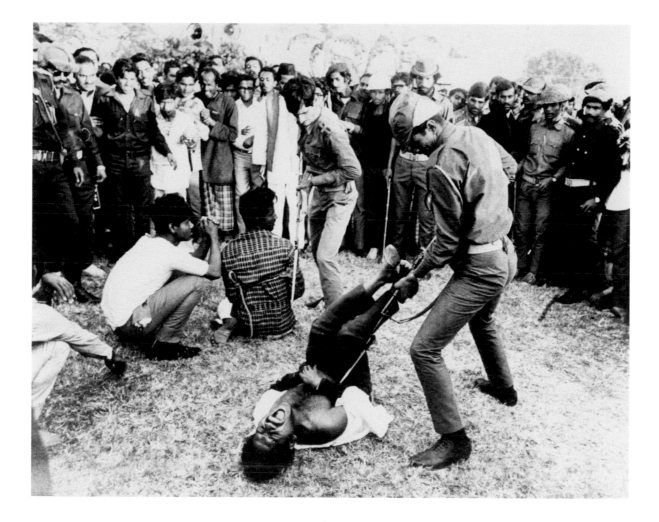

William Lovelace
Bayoneting in Bangladesh
1972

Switching Channels

'The television was fulfilling its
twentieth-century destiny as time machine,
memory purveyor and projector of
human life, ordinary and extraordinary.'

'Television… just seems an endlessly grinding thing –
a burning monk, an advertisement, and
Harold Wilson, and a pop show, and Jimmy Savile,
all seem the same sort of experience.'
— Dennis Potter

On 23 December 2006, my father saw his mother and father, although they – Harold and Eileen Higgins, born with the twentieth century – had been dead since the 1980s.

My parents had returned from a Christmas party at about nine o'clock. My father switched on the television to wait for *Match of the Day*. My mother, as my father dozed, idly watched what happened to be on BBC Two: a compilation of old amateur films recording family Christmases. All of a sudden, she recognised a face from long-ago visits to her parents-in-law.

She woke my father who emerged from his slumber to see the front door of his own childhood home, 16 Grove Avenue, Sheffield, on the screen in front of him. The neighbour's boys are ringing the bell. Judging by their age, it is the 1960s. The door is opened by his father. The camera follows the boys in and alights upon his beaming mother who sits at the piano and bashes out some carols. Clearly visible is a photograph of my mother, in her homemade wedding dress, on 25 June 1955, a figure as glamorously New Look as you could humanly manage in austerity Gloucestershire.

My half-awake father, as all this swims into view 23 years after his mother's death, momentarily believed he was dreaming. The show was called *Ghosts of Christmases Past*.

The footage had been shot by Kenneth Hawley, a man who had grown up in what my father describes as 'the house at the end of the garden'. When they were both boys, Hawley accidentally shot my father, with a gun this time (in the wrist; no lasting harm done). When Hawley grew up, he continued to live in his childhood home, and raised his sons there. He was an industrial historian, who amassed an important collection of Sheffield tools, including 1,000 table knives, 50 anvils and 2,000 planes. I know this because, in another curious coincidence, the artist Richard Wentworth (knowing nothing of these connections) forwarded me his obituary a week or so after I asked Dad to remind me of the story you have just read. Hawley died in August 2014.

I watched the programme too, when it was repeated shortly afterwards, and I can see myself sitting on the floor quite close to the small screen, so that I can almost enter that other room – that other room from a time before I was born – and here is the forgotten but suddenly familiar chintz of my grandparents' curtains, and there is the Palm Sunday cross on the fireplace. And somehow here too is the smell of my grandmother's food – roasted meat and vegetables boiled to oblivion; salad with hardboiled eggs, the yolks circled round with black rings; slices of Battenberg cake – and the mysterious sight of the air-raid shelter in the garden, and the sense of my grandmother's great-hearted kindness, and the atmosphere of my grandfather's deep and terrible sadness.

The television has always carried a certain suggestion of uncanniness, of images displaced out of time. John Logie Baird's first mechanical television was constructed from, among other materials, an old tea chest, a cardboard disc cut out from a hat box, a darning needle and an empty biscuit box. The early 30-line images that he produced from these humble and everyday objects in his studio in Frith Street, Soho, from 1925, resembled ghosts: half-resolved grey images, flickering. In his book *Armchair Nation*, Joe Moran recounts how some early owners of televisions did not care to undress in the same room as a switched-on set, for fear that they could be seen by the figures on the screen.

The notion of something's being 'switched on' originates in the electric age: first used in the 1880s, it relates to the directing of a current by means of a switch. In the third part of George Bernard Shaw's five-play cycle *Back to Methuselah* (1921) comes another early mention: in a scene set in 2170, two characters communicate by means of a telephone that also transmits pictures. 'Don't switch off', implores one. 'To switch on' is soon applied, metaphorically, to human attentiveness and interiority. In 1934 an article in the journal *Discover* refers to 'switching off any unpleasant dream'. By 1966 a writer in *The Listener* confides that 'I have always found it very easy to "switch on" emotion'.

What did it mean, this fact of the nation gradually 'switching on' – starting to see the events of the world, both serious and silly, simultaneously, despite geographical dispersion? BBC television – the first regular high-definition television service in the world – was relayed from Alexandra Palace in 1936, but was halted for the duration of the war. In 1945 it started again with the same cartoon that had been interrupted in 1939. Institutionally, the BBC was unenthusiastic about the new medium that the government had insisted it take up. It was widely seen as a mere novelty, a flash in the pan, fit only for crude entertainment. In 1947 BBC television was available to perhaps 20,000 people, all within a 40-mile radius of the transmitter at Alexandra Palace. (The march of the transmitters north and west happened gradually, under austerity conditions, in the early 1950s.) Only a few thinkers, such as Harold Nicolson, saw as early as 1939 that television 'may alter the whole basis of democracy'.

'BBC television – the first regular high-definition television service in the world – was relayed from Alexandra Palace in 1936, but was halted for the duration of the war. In 1945 it started again with the same cartoon that had been interrupted in 1939.'

Grace Wyndham Goldie was one of these thinkers. A crisp prose stylist with a rigorous mind, she had worked as a wireless critic for *The Listener* before the war, and in government service during it, devising systems for transporting pots and pans to bombed out areas. Then, in 1944 a call came inviting her to be interviewed for a position in the BBC talks department. She dazzled the panel of 'solemn-faced-looking BBC gentlemen', and soon moved into the spy Guy Burgess's former office on the second floor of Broadcasting House, where her first official encounter was with the BBC librarian, imploring her to be better behaved at returning books than her predecessor. In 1947 she made the move from wireless to television, to the department of another BBC intellectual, the geneticist Mary Adams, the head of television talks.

> 'In 1947 BBC television was available to perhaps 20,000 people, all within a 40-mile radius of the transmitter at Alexandra Palace.'

That same year she published an essay in a book called *Made For Millions* about the new mass communication. 'Television is a bomb about to burst', she wrote – rather a fearless metaphor only two years after real wartime bombs had ceased to fall. 'We have upon our hands, and in our midst, [a] great new force.' She recognised the essential qualities of live TV, which, in its early days, it nearly always was. 'The "teleview" has what the news reel has not – the dramatic quality of suspense', she wrote. 'When we see a news reel [at the cinema] of the Derby, we know already what horse has won: but when we watch a teleview we do not know this, and, what is more, we know that no one knows it.'

Television is projected reality, she wrote: 'What is taking place, there, in front of us, on the lighted glass panel of our receiving sets, is not a photograph or a film. It is the real thing: a black and white, two-dimensional representation of reality produced electrically by the reflection of light from the real objects and the real people.' She saw too how intimate a medium television was, and how ordinary. 'The texture as well as the tempo of life is retained in television as it cannot be in the cinema… a thousand subjects of everyday routine which are too ordinary for the cinema become excellent television material.'

Wyndham Goldie – a tiny, birdlike figure, but 'more of an eagle than a wren', according to David Attenborough – more or less invented television current affairs. She persuaded the BBC to let her cover the 1950 election results live on television, devising ways of conveying their meaning visually – giant maps, a 'thermometer' showing the progress of the main parties, a 'results board' in the

'The texture as well as the tempo of life is retained in television as it cannot be in the cinema... a thousand subjects of everyday routine which are too ordinary for the cinema become excellent television material.'
— Grace Wyndham Goldie

style of the Lord's scoreboard. No one, however important or well-connected, would now have access to an election result 'earlier than a shepherd in the Highlands or a housewife in Islington. The privilege of the few had once again been extended to the many', she wrote.

Wyndham Goldie surrounded herself with a group of arrogant, charismatic and brilliant protégés, all young men. Most of them had served in the war. She often said that her young directors needed to have the instant reactions of a fighter pilot to withstand the white-knuckle experience of live roadcasting. It was her men who invented the deference-slaying satire show of the 1960s, *That Was the Week That Was*. They also devised one of the first great history programmes to be shown on television, *The Great War*.

Marking 50 years since 1914, and broadcast on the brand-new BBC Two, the series mixed archive footage with testimony from survivors. It was the natural corollary of *Tonight*. Just as *Tonight* gave voice to citizens, so *The Great War* captured the experience of soldiers, who had been recruited via an advert in the *Radio Times*. Many veterans were still hearty, but it was clear that living voices would not be around for ever. This was oral history before it became a recognised branch of the academic mainstream. *The Great War*, with its stark, Bergman-like title sequence and dolefully portentous score, made immortals of these men, and transfigured the commonplace. It was capturing the ghostly images of men just a little older than my grandfather, whose experience would otherwise have been lost to history. The television was fulfilling its twentieth-century destiny as time machine, memory purveyor and projector of human life, ordinary and extraordinary. The bomb was bursting.

Roger Hiorns

'The population is now waking up from
its well-managed slumber because of these
successive public abuses.'

When bovine spongiform encephalopathy (BSE) first emerged in the press I was studying at Goldsmiths. At the time, the newly discovered variant Creutzfeldt-Jakob disease (vCJD) notably affected farmers. The threat it posed was also age specific; it was causing early dementia and fatal brain disease in younger people. My contemporaries and I were the target group of this disease. During those years, we all reacted differently to the crisis. Some listened to the scare stories and decided they weren't going to eat meat at all, others ate more in an attempt to reject the influence of the state. Being in the dark about a potentially fatal disease created an unusual social environment: for an achingly long period in the mid-1990s to the mid-2000s we were connected by a collective dread.

BSE and vCJD – the version of the disease that affects humans – not only had immediate and lasting ramifications on politics, science, culture and society, it also revealed the various systems and structures within which governments and societies operate. The diverse material in this exhibition, from scientific objects and phenomena to artworks, official governmental reports and news stories, forms one vast collage; a deluge of raw information that is punctuated by the arts and humanities. Much of the material featured in the exhibition is extremely complex and requires a huge amount of unravelling, close reading and cross-examination. This level of time and attention, however, is something that is impossible to demand of a viewer. With this exhibition I have tried to push the limits of how we should behave as curators and viewers. It has been important to propose 'too much', to create a short-circuit of information, to simply allow the viewer to make their own path through the subject.

The artworks in this exhibition represent various periods or episodes in the story of BSE and vCJD. While some have associative importance, others – such as Gustav Metzger's *Mad Cows Talk* (1996) – respond directly to the crisis. In bringing together such a diverse range of objects and artworks, new relationships have been forged; Clark's shape-changing *Parafuso sem fim* (1963), for example, recall the misshapen prion protein, exhibited here as a 3D model, which, within the affected brain, attaches itself like plaque to brain matter and causes the fatal conditions.

While all of the material is a character within the story of BSE/vCJD, the official reports produced by organisations such as the Spongiform Encephalopathy Advisory Committee (SEAC) – formed in 1983 – have particular importance. In the early days of the crisis it was through a series of convening groups and the production of official reports that the authorities began unravelling the mystery of 'Mad Cow Disease'. These reports provided essential guidelines about how to behave and are therefore vital documents for any reassessment of the crisis. That we are able to dig deep into material such as this and look closely at a phenomenon such as BSE/vCJD is, I believe, important if we are to learn to keep our heads as a progressive society.

The moment in May 1990 when the Agricultural Minister, John Gummer, publicly fed his daughter potentially contaminated meat was – I believe – the moment when the public lost their faith in the governance of this country. Gummer's act was seen as part of a refusal to tell the whole truth in a time of public jeopardy and, to many, he appeared to be putting the meat industry – a great creator of wealth – above the health of the population. This distrust can be linked to the public's profound dissatisfaction with the present idea of government. This, I believe, makes a reassessment of the BSE/vCJD crisis an extremely timely one. The population is now waking up from its well-managed slumber because of these successive public abuses.

Although the subject abated in the press, the crisis never reached a resolution. The origin of the disease is still under debate; so too is the incubation period of the prion agent, which could potentially be incubating within 2 in 4,000 of the population. The threat that the disease poses to national and global health is, therefore, still considerable. Over the last 20 years, however, our attitude to personal risk seems to have changed. Perhaps as a consequence of our increasingly predatory capitalist environment, such potential health risks are increasingly seen as unavoidable – merely part of the system that we exist within, a population caught in the binding chain of systemic violence.

William Kidd
Death of Poor Mailie
c.1833–55

Charles Jones
Sheep
1875

Tony Ray-Jones
Picnic, Glyndebourne 1967
1967

Bovine spongiform encephalopathy - Government Policy - Great Britain

0 1 SEP 1997

BSE: CULL POLICIES AND THE DISEASE

- Modelling the disease in cattle
- Implications for cull policy
- Latest implications for human health

POST TECHNICAL REPORT 85
October 1996

POST reports are intended to give Members an overview of issues arising from science and technology. Members can obtain further details from the PARLIAMENTARY OFFICE OF SCIENCE AND TECHNOLOGY (extension 2840).

Scientific understanding of the factors affecting the spread of BSE among UK cattle has advanced since the last POST review[1]. More information is available on the **incubation period** and on the extent of **maternal transmission** between infected dams and their calves, and epidemiologists at Oxford University have refined **mathematical models** to project the shape of the epidemic in the years to come, assess the likely impact of different culling options, and estimate the numbers of infected cattle which have entered the food chain.

This note describes these developments and examines the policy implications that arise.

MATERNAL TRANSMISSION

One area of uncertainty regarding the BSE epidemic was whether maternal transmission occurred between dam and calf. Some scientists had argued that since this took place with scrapie in sheep, the likelihood was that it could also occur with BSE in cattle. MAFF vets maintained that the number of BSE cases could be explained on the basis of exposure to infected feed, indicating that if cows were able to pass the disease on to their offspring, it was occurring at a *"very low and undetectable frequency"*[2].

An experiment to resolve this question was set in train at the Central Veterinary Laboratory (CVL) in 1989 to follow two groups of calves - one of each pair (the 'control') had been born to a dam which had not developed BSE (by age 6); the other had been born in the same herd and season, but from a BSE-affected dam. The original intention was to keep all animals for 7 years (i.e. to Nov 1996), or until they developed BSE (or another disease). However, due to the importance of the study, preliminary results were released up to July 1996, by which time data were available from 273 animals in each group.

The findings are shown in **Figure 1** which shows that calves born to infected dams did have a 10% 'excess' risk of contracting BSE. However, the fact that 5% of calves in the control group developed BSE shows that they must have been exposed to contaminated feed before they entered the study. This complicates interpretation, since the results could (in whole or part) be due to calves sharing with their mothers a genetic

CONTENTS

Figure 1 PRELIMINARY RESULTS FROM THE CVL MATERNAL TRANSMISSION STUDY

predisposition to catch BSE from feed[3]. **This experiment has thus not resolved the question of maternal transmission.** It may be possible to pin down the cause more precisely using the expertise at Oxford University, if access can be given to the original experimental data from the CVL study.

If it turns out that maternal transmission is direct however, we need to know how far the risk is related to the state of the dam's infection. According to the Spongiform Encephalopathy Advisory Committee (SEAC), the detail of the CVL study provides some evidence that the **risk of maternal transmission is greatest in the 6 months** before dams develop actual BSE symptoms. Since most of the infected dams in the CVL study were in this category, MAFF suggest that the 10% figure should apply only to dams about to develop clinical symptoms. If it is assumed that the 6 month period is a 'cut-off', with calves born before it being at little risk of infection and those born after facing a 10% transmission rate, then SEAC estimates that the overall risk of a calf acquiring BSE from an **infected** mother would be nearer 1%.

1. BSE and CJD: Science, Uncertainty and Risk, POST Rpt 78, April 1996.
2. SEAC 1994 (A Summary of Present Knowledge and Research), p39.
3. MAFF analysis suggests that the risk of BSE is higher in the calves born before the 1988 ruminant feed ban than after, which would not be expected if the transmission were direct from infected cow to calf, but would be consistent with a genetic susceptibility component.

Report 85 *October 1996*

...ic in the UK from the mid-...sts that the disease has an ...years between infection ...oms. Thus the first BSE ...til 1986, some years after ...e of cattle to infected meat ...d feed in the late 1970s or ...several years before the ...ycling ruminant-derived ...988) had any noticeable ...BSE cases (which started ...ure 1, POST report 78).

...ecently emerged into how ...d varies within the cattle ...dose or route of transmis-...ps of cattle were fed with ...f 1g, 10g, 100g and 3x100g ...it is on-going, but interim ...ns suggest that BSE signs ...r so- first in those cattle ...(100 g or 3x100g), subse-...g the lower doses (from 44 ...als receiving the 3x100g ...me given 1 or 10g are still

...l transmission found an ...ibation period:
...d 5 years, with most ani-...o 7 years after infection;
...ose received (higher doses ...od).

...E EPIDEMIC

...n recently to the results of ...epidemic in British cattle ...Centre for the Epidemiol-...Oxford University. This ...idemic to date, projects the ...epidemic, and can be used ...t of culling options.

Mathematical models to project the future course of a disease epidemic have been in use in medical circles for many years and much work has gone into their refinement in order to inform public health policy (e.g. on vaccination campaigns), as well as predicting the possible course of the spread of HIV/AIDS. As discussed in **Box 1**, these models describe the course of the disease by calculating the number of uninfected, infected and diseased individuals, and include the factors that influence the 'flow' of the disease (transmission rates, incubation periods, etc.). Where full information is avail-

Box 1 APPLYING EPIDEMIOLOGICAL DISEASE MODELS TO BSE

Epidemiological models apply knowledge of the course of a disease in individuals to the study of its transmission within a population. The first step in constructing such a model is to split the population up into different categories depending on their disease status. This idea is illustrated in the Figure, which shows a simplified model of the various factors relevant to the BSE epidemic. The three main categories within the cattle population (depicted as boxes in the Figure) are:

- susceptible cattle (those not infected);
- infected cattle (which carry the infectious agent but do not yet display signs of BSE);
- cattle with clinical signs of BSE.

In principle, modelling the progression of a disease within the population is achieved by calculating the numbers in each category over time. This requires two further steps. Firstly, mathematical equations must be devised to describe the flow of the disease from one category to another (depicted as arrows in the Figure). In the case of BSE these would have to take account of changing birth-rates over the course of the epidemic, feed-borne transmission rates (which vary with time and with age), maternal transmission rates, slaughter rates (most infected animals will be killed before they develop clinical signs of BSE) and the characteristics of the incubation period.

Secondly, basic data on the number of individuals in each category are required, in order to define the state of the epidemic at the start, from which point the number of affected individuals in each category over successive periods of time can be calculated, and the likely future course of the disease projected. Such approaches have been successfully used to model a range of diseases in humans (e.g. to inform public health policy regarding vaccination programmes). However, the case of BSE presents particular problems, since the lack of a diagnostic test means that there is no way of distinguishing uninfected (i.e. susceptible) animals from those which have the infection but which have not yet developed BSE symptoms. In the event, valuable experience had been accumulated in developing epidemiological models for infection by HIV and progression to AIDS, and it was possible to build on this in developing techniques of back-calculation to model the BSE outbreak.

Figure A SIMPLIFIED MODEL OF BSE IN CATTLE

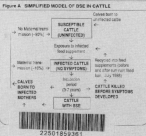

2 22501859361

able, the model can both explain the cu... and project the disease's likely future cou...

Information is available on the numbers with signs of BSE, the incubation period, maternal transmission, the effects of slaughter patterns in removing animals before developing BSE, and on other factors. Due to the lack of a diagnostic test for infection however, no direct information on the number of **infected** (but asymptomatic) animals is available. Instead, the pattern of infection throughout the epidemic has to be deduced by **back-calculation**, developed from methods used to model the progress of the HIV/AIDS epidemic. In this way, the number and age of infected animals in the cattle population at any given time is 'reconstructed' by working backwards from MAFF and Scottish Office (SO) records of the number and age of confirmed BSE cases throughout the epidemic.

Several factors in the model are known only approximately - e.g. the extent of under-reporting of actual BSE cases (most likely in the early stages of the epidemic), how many infected animals were slaughtered before they had time to develop BSE signs[4], the exact variation in the incubation period, the variation in risk of feed-borne infection with age and time, and the maternal transmission rate. The scientists thus ran a large number of different 'versions' of the model, each making different assumptions to find which set best explained the historical pattern of confirmed BSE cases and their age. The best 'fit' was found with a model that assumed:

- an incubation period with a mean of 5 years, but ranging from 2 to 9 years;
- the susceptibility to feed-borne infection peaks at age one, and declines rapidly thereafter;
- a maternal transmission rate of 10%, but only in the last 6 months of the dam's incubation period.

This model gives the trends in the incidence of infection shown in **Figure 2**. This has the first infection starting to develop by 1983, after which the number of new infections and the total number of infections rose steeply until the feed ban was introduced in 1988. After the ban, **new** infections declined rapidly, accompanied by a slower tail-off in the total number of infected animals. Due to the long incubation period, there is a considerable lag between the peaks in new infections (1988) and observed BSE cases (1993). The model confirms that the **number of diagnosed BSE cases was just the tip of the iceberg** - only around one third of animals having developed BSE signs appear to have been reported up to 1988, and many more animals were infected but slaughtered before the disease had time to develop fully. Overall, best estimates suggest that around 900,000 animals had been infected by 1995. Of these, only

4. Most cattle are slaughtered at age 2-3 years, so the majority of infected cases would not have had time to develop clinical signs of BSE.

3

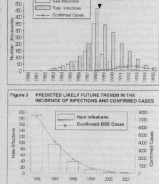

Figure 3 PREDICTED LIKELY FUTURE TRENDS IN THE INCIDENCE OF INFECTIONS AND CONFIRMED CASES

around 160,000 (~18%) had actually developed BSE signs, with **the vast majority of the rest (729,000 or ~81%) entering the human food chain after being slaughtered,** both before and after the ban on the use of offals for human consumption in 1989 (see later).

If a maternal transmission route is established as the source of new infections, the model suggests this is sufficient to account for recent new infections. Contaminated feed may have thus ceased to be a significant source of new infections after 1994. Since the maternal transmission indicated in the CVL study is too low to sustain the epidemic, as shown in **Figure 3**, the model predicts that **new infections will fall** from ~189 in 1996 to just 1 by the year 2001. Because the key factors are not known precisely, different values and functional forms were used in the model runs. These gave a range of predictions, 95% of which fell between 155 and 11,300 new infections for 1996, and between 0 and 33 for 2001. Trends in the number of confirmed BSE cases will, of course, lag behind the fall in infections, and are predicted to drop from ~7,400 (95% prediction limits 6,500-8,900) in 1996 to ~70 (45-1600) by 2001 (also in Figure 3).

ASSESSING CULLING OPTIONS

Once established, the model can be run under different culling policies, to see what effect they have on the future shape of the epidemic. Many options have been analysed by the Oxford Group, from a total cull of all

BSE: Cull Policies and the Disease.
POST Technical Report 85 (detail)
October 1996

June Bridgeman, Nicholas Phillips,
Malcolm Ferguson-Smith
The BSE Inquiry Report
2000

Cattle ear tags

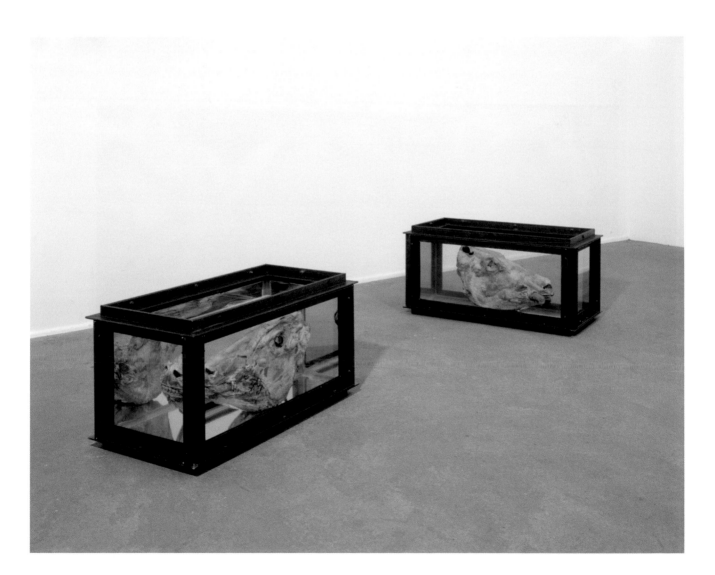

Damien Hirst
Out of Sight. Out of Mind.
1991

Jørgen Leth and Ole John (dirs.)
'My Name is Andy Warhol' from 66 Scenes
from America (66 scener fra America)
1982

BBC Motion Gallery Editorial/BBC News
*Minister of Agriculture John Selwyn Gummer tries
to feed a burger to his daughter to prove British
beef is safe; she refuses so he eats it himself*
16 May 1990

RISKS ASSOCIATED WITH IMPORTS OF BEEF AND SHEEP PRODUCTS FROM OTHER MEMBER STATES

20. Also in May 1997 SEAC considered the issue of imports into the UK of material containing tissues from bovine central nervous system (CNS) in the light of existing controls on bovine risk materials in the UK and elsewhere. It took into account the EU Commission's assessment of surveillance and control in other Member States. SEAC concluded that action should be taken to extend, within the UK, controls on specified bovine material (SBM) to imports of CNS or bovine material containing CNS from the EU, and from third countries - other than those where there is no known risk of BSE. Again, it would be preferable if action could be taken on an EU wide basis but if agreement in Europe could not be achieved quickly, unilateral action by the UK was recommended.

INFECTIVITY IN DORSAL ROOT GANGLIA AND THE SAFETY OF MEAT

21. In December 1997 the Committee considered a report on the risk to consumers following the detection of infectivity in nervous tissue called the dorsal root ganglia (DRG). Under experimental conditions cattle were fed 100g of BSE-infected bovine brain. They later developed infectivity in the brain, spinal cord and DRG. The latter lie within the bones of the spinal column and would be left with the bone when meat is cut off the spine. The DRG were not at that time covered by the specified bovine material (SBM) restrictions. Preliminary findings indicated that infectivity might be found in the bone marrow of cattle at a very late stage of disease and showing clinical symptoms. The significance of the results on bone marrow was difficult to judge at the time and the Committee decided to consider this further when the experiment was complete.

Although the risk from infectivity in DRG was thought to be extremely small, SEAC recommended that the public should be informed immediately, and presented the Government with measures it could take if it felt such a risk was unacceptable. One option was to require that all beef from cattle over 6 months old should be sold with the bones removed, ensuring that DRG were not inadvertently eaten. This was the policy adopted by the Government and the Beef Bones Regulations 1997 came into force on 16 December 1997

GELATIN

22. The production and use of gelatin, which is used as a gelling agent in a variety of foods and cosmetics and is also used in the manufacture of pharmaceuticals, was reviewed by the Committee in October 1997. (Gelatin is manufactured either from hide material or bones.) The Committee noted that plants in the UK manufacturing gelatin for food, feed, cosmetic, medical or pharmaceutical use have been brought under official control. The Committee

11

A. Protection of human health

HUMAN BLOOD AND BLOOD PRODUCTS

16. At their meeting in October 1997 SEAC recommended that the National Blood Authority adopt a precautionary policy of extending the leucodepletion of blood as far as practicable pending the results of an assessment of the risk of transmitting nvCJD by blood.

ROUTES OF EXPOSURE

17. In February 1998 the Committee considered a preliminary analysis of the possible ways by which BSE infectivity may have entered the human food chain over the course of the BSE epidemic. The Committee noted that this preliminary analysis required detailed review and substantial revision.

CATTLE AND SHEEP AUDIT TRAIL

18. In July 1997 the Committee considered the final report, prepared by Leatherhead Food Research Association (LFRA) for MAFF, on the potential routes of exposure to BSE through the historic sale of potentially infected tissue from bovines and sheep. The purpose of this audit was to provide an overview of the slaughtering, rendering and by-products industries for sheep and cattle in the period 1980-1995. Much of the report was based on anecdotal evidence, and the Committee was keen to validate the information it contained before publication.

SHEEP AND GOAT MEAT: SPECIFIED RISK MATERIAL (SRM)

19. During the year, the Committee concluded that all sheep and goat heads should continue to be treated as SRM. In addition, in May 1997, the Committee said that the spinal cord from sheep and goats with a first permanent incisor should be removed and treated as SRM and that the use of the vertebral column for mechanically recovered meat (MRM) should be banned. The Committee concluded however, that the production of tallow and gelatin, which involved a high degree of processing, could be permitted from sheep and goat vertebral column. The Committee recommended that these restrictions should also apply to imported sheep and goats (except those from scrapie-free countries).

10

also noted that all UK gelatin manufactured for these purposes from bovine raw material utilised only imported ingredients. They noted that implementation of Commission Decision 97/534/EC would exclude Specified Risk Materials from the source materials used for gelatin manufacture in all Member States. The Committee decided they needed to make no further recommendations on gelatin: UK controls were re-assuring.

TALLOW

23. As a by-product of the rendering industry, tallow is used in food and feed and for cosmetic, pharmaceutical or medicinal purposes. As with gelatin, it too was affected by the export ban. In October 1997 the Committee also reviewed the production and use of tallow. It noted the restrictions in the UK on the sources of raw material used in the production of tallow and was impressed by UK tallow production controls. The Committee noted that imported tallow was not subject to the same restrictions nor required to reach the same standards but that the implementation of Commission Decision 97/534/EC would result in the exclusion of Specified Risk Materials from the production of tallow across all Member States from January 1998.

SAFETY OF MILK

24. In the New Year the Committee reviewed the processing and use of milk. In particular, they considered the relevance of recent research publications implicating lymphocytes in the pathogenesis of TSEs. The Committee noted that there was no evidence of infectivity in spleen or lymph nodes of cattle infected with BSE. No changes were made to the previous advice on the safety of milk: SEAC confirmed that it considered current measures to protect the consumer to be appropriate.

WATER FILTRATION

25. The Committee considered the use of bovine bone charcoal for water filtration. They noted that the bones came from countries which had no reported cases of BSE, were sun-dried and bleached and that the production method included heating to 1000°C. Consequently they concluded in January 1998 that the practice could continue.

B. Protection of animal health and monitoring

SAME SPECIES FEEDING

26. The Minister of Agriculture, Fisheries and Food asked SEAC to review the practice of feeding animal by-products to animals of the same species. The Committee recommended in December 1997 that the Government develop a

12

Spongiform Encephalopathy Advisory
Committee (SEAC)
Annual Report (detail)
1997–98

Box of 22 histological
slides showing sections
of mouse brain from
mice infected with scrapie
1998

Safety cabinet used at the Institute for Animal Health in Edinburgh 1980s

Department for Environment, Food, & Rural Affairs (DEFRA) *How to detect signs of Foot and Mouth in cattle, pigs and sheep. Steer with 2-day-old ruptured vesicle along upper gum and several 1-day-old unruptured vesicles on the tongue*

Prionics Ag Switzerland *Prionics®-Check WESTERN Kit, Article 12000: Test for in-vitro detection of TSE-related PrPSc in cattle*

Animal Health and Plant Agency
Clinical Signs of Bovine Spongiform
Encephalopathy in Cattle
2013

Bovine Spongiform Encephalopathy (BSE)
Advisory Notes for Farmers
2009

Bovine Spongiform Encephalopathy
Research Paper 95/132
20 December 1995

Laurène Pijulet-Balmer
Under Your Skin: Creutzfeldt–Jakob
2013–14

MRI scan of a human brain displaying
progression of vCJD

Nicolaus Geyrhalter (dir.)
Our Daily Bread
2006

Did you know? Nº3

100% PURE BEEF — The Facts

Food hygiene and quality have always been important to McDonald's.

There has been much debate recently regarding the quality of meat used in pre-cooked meals, convenience foods and in the fast service restaurant industry. McDonald's attention to high standards in this area is not a debatable point.

ONLY prime cuts of lean forequarter and flank are used for their 100% pure beef hamburgers.

No additives; no fillers; no binders; no flavour enhancers. Just 100% pure beef.

All McDonald's beef comes from EC-approved European suppliers. Every consignment of beef arriving at the meat plant is subject to a total of 36 separate quality control checks, carried out by a team of qualified technologists. If a consignment should fail on any one check—it will be rejected by McDonald's.

In addition, a Ministry of Agriculture representative visits the plant weekly, to monitor its hygiene standards, as well as the quality of the beef.

McDonald's commitment to quality is paramount throughout the production and preparation of all its products, to ensure that customers receive only the highest quality food and beverage.

Produced by:
The Public Relations Department
McDonald's Restaurants Limited
11-59 High Road
East Finchley
London N2 8AW

FACT SHEET

THIS INFORMATION IS PRINTED ON RE-CYCLED PAPER. 6/90

The McDonald's Corporation
Did you know, No 3
1994

London Greenpeace
Anti-McDonald's Fayre
1988

Robert Bygott (dir.)
*Kuru: The Science and the Sorcery. Dedicated
to the Fore and other people who suffered
from the kuru epidemic in Papua New Guinea*
2010

The first investigation of vCJD using a western blot to detect rogue prion proteins present in the brains of patients 21 May 1996

‘About Andrew’ from justice4andy.com
2014

Lygia Clark
Parafuso sem fim
1963

Roger Hiorns
Untitled
2008

Ribbon Representation of Human Prion Protein
2014

Mad Cows:
A Low Dishonest Decade

'It was ten years that triggered a deep, continuing,
public disillusion with politicians and experts.'

'Like a virus, but different – the BSE pathogen is coded by the host, so the cow's immune system doesn't detect it... It affects then destroys the central nervous system. Believe incubation period is 4 years.'

'I didn't know then that it was going to be a story that would reshape British attitudes – and not just to food.'

On 1 December 1988 I began my first notes on bovine spongiform encephalopathy (BSE), in one of those hardback foolscap notebooks that in pre-computer days BBC journalists were advised to write all their notes and contacts' details in.

They start with a record of a conversation I'd had with *Farming Today* reporter and presenter Dylan Winter. He'd read an article in the *Veterinary Record* showing that if you injected tissue from cows infected with BSE into the brains of several sets of genetically different mice, one set, with a particular genetic make-up, developed spongy brains. He'd also been following the doings of what was then an obscure Whitehall working party headed by biologist Sir Richard Southwood. It had been set up to consider whether there was any risk to human health from the newly discovered disease.

So I set off on my own journey into the ABCs of food and farming, disease and power. I didn't know then that it was going to be a story that would reshape British attitudes – and not just to food. Or that it would reshape me. I'd had my journalistic Damascene moment in New York when I realised that writing about food was a powerful and mostly un-trodden way to understand the world. I'd then spent nearly three years at a magazine there investigating the collusion between government and commercial interests. But the USA is a big place and it was hard to get close enough to any story to see, day to day, how that collusion works in all its subtle ways. For this story I was in London, physically just a walk away from where decisions were being made.

Many scientists now think BSE first appeared in cows in the 1970s, but the animals were sent to slaughter and no post-mortems were done. The cow that got the story going had been raised on a farm in Sussex. In 1984 the farmer called in the vet because the cow was tottering around the yard, arching her back, shaking her head from side to side. She was put down and her head sent to the government's Central Veterinary Laboratory (CVL).

The CVL took her brain apart and discovered a new disease, bovine spongiform encephalopathy – spongy brain in cows. By mid-1985 the CVL was seeing other cows with the same symptoms. But they didn't officially notify the Ministry of Agriculture about the disease until June 1987. By then there were four dairy herds in the country with tottering, head-tossing cows.

Where had the disease come from? When I stumbled on the story the dominant theory was their feed – and it's still the dominant theory. I was surprised to learn that for decades cows had been eating the mashed remains of sheep. And some of those sheep probably had scrapie, a disease similar to BSE, known to have been in British flocks for at least 200 years.

One of the first people I spoke to was geneticist Dr Alan Dickinson. He'd been the founding director of the Agricultural Research Council and the Medical Research Council's Neuropathogenesis Unit at Edinburgh University, one of two centres in the UK that specialised in scrapie and similar diseases, but had since left the unit. Dr Dickinson had found himself an early victim of the new orthodoxy in government circles: research couldn't be done in response to scientific curiosity; it must be useful to the market. Or, as he said in 1998 in his evidence to the BSE Inquiry,

'Dr Dickinson had found himself an early victim of the new orthodoxy in government circles: research couldn't be done in response to scientific curiosity; it must be useful to the market.'

'One element of the BSE disaster lay in the slow politicisation of the Research Councils... the political intention, from 1971, was to curtail expenditure by the Research Councils and redirect their research choices into so-called "consumer/ contractor" priorities and leading eventually to "corporate planning" styles of management.'

There'd been no evidence until the Sussex cow that scrapie could jump species. But, as Dr Dickinson said, any attempt to find evidence had been actively discouraged by the two ministries funding the UK's neuropathogenesis research. I learned that cows weren't only being fed sheep, they were also eating other cows. The poor creatures had been turned into cannibals. There were chicken droppings in the feed too, along with whatever slaughterhouse waste was available that week. Not that farmers knew. Years before, the government had given into the animal feed companies pressuring it to cut the requirement to list ingredients on feed bags. Soya beans, chickens, sheep, chicken droppings or cows – it was all the same 'protein' on the label.

But why were cows – herbivores – being fed animal remains? I interviewed the Ministry of Agriculture, Fisheries and Food's (MAFF) Chief Vet Keith Meldrum. It was basic economics, he said – without cheap, protein-packed feed, milk production wouldn't be cost effective. When cows are fed on grass and hay they produce milk at the rate they'd need to feed a calf or two. Supercharge their diets with concentrated protein and you could treble or quadruple production. Keeping milk cheap. And cheap food had been UK government policy since the end of World War II.

Why in the face of the BSE outbreak Mr Meldrum was so sanguine that BSE was not a problem wasn't clear, but Mr Meldrum was all confidence. As he told me before I turned on the microphone, he didn't know why I was making such a fuss, covering a story just to agitate people – British meat was perfectly safe.

Still, the questions continued to come. If, as Keith Meldrum told me, cows had been fed sheep and the other carnivorous dainties for years before BSE appeared, why had the disease appeared now? The answer was also related to 'cost effectiveness'. In the late 1970s the animal feed industry had changed the way it processed slaughterhouse waste from a high temperature system to a low temperature one. And the prion – the DNA-less, misfolded, infectious protein that appears to cause

scrapie, BSE and similar neurodegenerative diseases – is hard to kill. As far as I could discover, the new money-saving processes had been introduced without any serious tests on what effect they might have on the safety of the feed.

But so far this had been a story about animals. As I worked my way through a long list of potential interviewees – most of them unwilling to talk to me – it became clear that the scientists who knew most were worried the most about the disease jumping to humans. Off-the-record, members of the government's Southwood working party were worried. On the record, in their official report the following year, they concluded that it was 'most unlikely that BSE would have any implications for human health'.

But what serious reason was there to think that humans were at risk from BSE when we'd all, apart from vegetarians, probably had more than a taste or two of scrapie?

> 'The fact that the disease has occurred in cattle was a surprise...' I was told by Dr Hugh Fraser, one of the country's leading experts on BSE. 'Can it be passed on to humans? We'd be quite wrong to be complacent. My own prejudices are that the likelihood of it being a human health hazard is remote. But remote is not negative. We don't know. That's all we can say. But, it would seem sensible to remove the infectious matter: the spleen and other nervous tissue from beef carcasses before they go into the human food chain [...] though we need to know more about the meat processing industry.'

What Hugh Fraser wouldn't let me record was his answer to my question about whether he'd changed his own diet as a result of his research. The answer was, he had. Like a number of his colleagues, he no longer ate meat pies or sausages or tinned sauces that might contain beef offal.

Like Hugh Fraser I wanted to know more about the meat processing industry, but the industry wasn't talking to journalists. Fortunately, David Roberts, Chief Trading Standards Officer in Shropshire, knew a lot about the industry and was happy to be interviewed. He described the hydraulic machines that crushed animal carcasses after the butcher's knife had removed all the meat reachable by a blade. Bone, spinal cord, gristle were all crushed into a grey slurry – mechanically recovered meat (MRM), perfectly legally used, he said, 'in a wide variety of meat products'.

Because MRM is particularly suitable for dishes containing meat pastes and ground meat, infected tissues were going into meat products that were being made into foods most commonly eaten by children. This didn't matter, Chief Vet Meldrum told me, because 'we believe that farmers are complying with their legal and moral obligations and are reporting suspect BSE cases to the ministry at the earliest opportunity.' So, all BSE infected cows would be slaughtered and burned.

The weakness in Mr Meldrum's argument was that, first, infected cows were infectious for years before symptoms were obvious. And, second, the ministry was only paying farmers half the compensation for a cow reported as having BSE as they would for one slaughtered as a 'casualty'. They were losing £300 on every BSE cow.

Not until November 1989 did it become illegal to put spinal cord and other possible infectious tissues into MRM slurry. And it wasn't until February 1990 that farmers began getting 100 per cent compensation for cows killed for BSE

'Because MRM is particularly suitable for dishes containing meat pastes and ground meat, infected tissues were going into meat products that were being made into foods most commonly eaten by children.'

symptoms. But the official line remained the same: as two of the country's Chief Medical Officers, Sir Donald Acheson and then Sir Kenneth Kalman, put it, 'British beef is safe to eat'. And who can forget John Gummer, then Minister of Agriculture, feeding his daughter a hamburger to prove the government's point?

Even when the scientific evidence showed that BSE was moving on to other species – goats, deer, cats – the government message didn't change. Even when 19-year-old Stephen Churchill died in 1995 of a new variant of the rare degenerative disease, Creutzfeldt-Jakob Disease (vCJD), the government dismissed the idea there could be any link with BSE. Only in March 1996 didgovernment Health Minister Stephen Dorrell announce in Parliament, as a result, finally, of undeniable evidence, that BSE and the new disease vCJD were 'probably' linked.

Yet still the government continued to avoid making links between BSE and any threat to human health by declaring, along with the meat industry, that the 'probable' link between BSE and the new vCJD disease was the result of practices since modernised by the private sector. By this time, however, the government was fighting a losing battle. A week later the European Union banned all exports of British beef. What government and industry had fought to protect through ten years of obfuscation, lies, hypocrisy, intimidation and double-think had come to pass anyway.

Young people died horrible deaths. British farmers lost millions, thousands of them left dairy farming and British taxpayers lost billions. It was ten years that triggered a deep, continuing, public disillusion with politicians and experts. For ten years the message was that British beef was safe. But people had been watching cows go mad on their nightly news programmes. They saw that herbivores had been turned into cannibals and in interviews from Ullapool to St Austell they told reporters it was 'unnatural'. Numerous experts lectured us on the absurd naivety of such a view, but we'd all seen what we'd seen and it was unnatural. When Tony Blair and his successors tried to enthuse us about GM foods, they discovered the power of the scepticism that government had nurtured.

But something good also came out of this sorry chapter of British food history. Suddenly it wasn't just the policy wonks who were concerned about the food system. Everyone had seen that cheap food had a cost. Is it a cost worth paying? That's a discussion we're still having and it all began with BSE.

Simon Fujiwara

'The government now understands that
the immaterial is valuable in financial terms:
happiness is a GDP.'

One of the starting points for this exhibition is Daniel Fujiwara's work as an economist. Daniel, the artist's brother, works in 'Happy Economics', which is the attempt to quantify, in monetary terms, the nation's wellbeing and happiness. In recent years the British government's interest in experimental economics that work with the 'softer' parts of culture – arts, emotions and happiness – has been growing, as has the interest of large companies. Placing a value on something as abstract as happiness can be understood as a powerful symbol of an optimistic, late-capitalist moment. The government now understands that the immaterial is valuable in financial terms: happiness is a GDP.

Britain is a country that has now largely ceased to produce. Instead, it is concerned with services, education, lifestyle and entertainment. While the shift from material production to immaterial production is not solely a British trend, the objects, artworks, minerals and food items in this section trace its development and manifestation in modern Britain. The exhibition opens with the navy suit worn by the actress Meryl Streep while playing Margaret Thatcher in the 2011 bio-epic *The Iron Lady*. It was under Thatcher that the values of gold and currency were first separated, and that the accelerated process of dematerialism of labour and capital took place.

Growing up in Cornwall, the artist attended a small private primary school of around 20 students. In the year that the school staged the musical *Mary Poppins*, Fujiwara took a leading role as Mr Banks – the head of a bank who never sees his children because he's too busy working. In the opening scene, Banks celebrates the rising power of the British pound, ignoring his strained family relations. In a subsequent scene, Banks's children go up a chimney with Bert the Chimney Sweep. Finding it dirty and scary, the children initially don't want to enter the flue, but are eventually persuaded to by a song about how wonderful it is on the city's rooftops. This song functions as a kind of 'edu-tainment'; it turns a difficult, dangerous job into something admirable and almost magical, while celebrating London's skyline – now very much a commodity in itself.

The tabloid presence of the Young British Artists in the 1990s made them the first generation of artists to be accessible to a larger, rural audience. Works by artists such as Gavin Turk, Ceal Floyer, Sam Taylor-Johnson and Damien Hirst caught the public's attention, either with their use of biography and the 'personal story', their engagement with the art market and auctions, their relationship with celebrity, or the simplicity of the work itself. While the black bin bags by Turk and Floyer that appear in this exhibition – in one case filled with air, in another cast in bronze – may recall the dustmen's strike of the 1970s (before Margaret Thatcher's intervention), a series of brooms used to clean up after the London riots of 2011 echo more recent public discontent.

In modern Britain, public buildings often partner with private companies to produce forms of public space that function as something between advertisement, artwork and urban structure. Due to its brutalist architecture, the National Theatre is a building with a long history of controversy in Britain. In 2007 it was decided that it would be enlivened by an external lighting system sponsored by the electronics company Philips. This lighting system transformed the building's facade, turning it bright pink, purple, blue or green. These colours add a new hue to the building, which both attracts tourists and re-narrates a controversial history – in this case the history of brutalism – to create a more purposeful, positive skyline of London. Positivity and optimism are key terms for this exhibition, as they are for twenty-first century Britain.

Consolata Boyle
Costume designed for Meryl Streep in The Iron Lady
2011

Simon Fujiwara
Script from school performance of Mary Poppins
1991

Chimney Sweep Broom
2014

*Local residents in Hackney clean up following
the 2011 England Riots*
2011

Atspeed
Balcoform Platinum Clearview Walk-On Balcony
2014

Ryan Gander
Make everything like it's your last – Gun
2013

The Clink Restaurant, HMP High Down,
Banstead, Surrey

Nigella Lawson Living Kitchen
Serving Hands

Ceal Floyer
Garbage Bag
1996

Gavin Turk
Bag (9)
2001

Mined, unprocessed coal

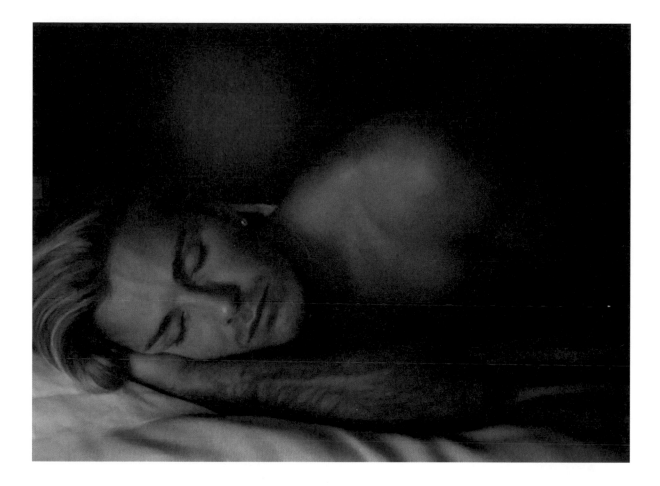

Sam Taylor-Johnson
David Beckham ('David')
2004

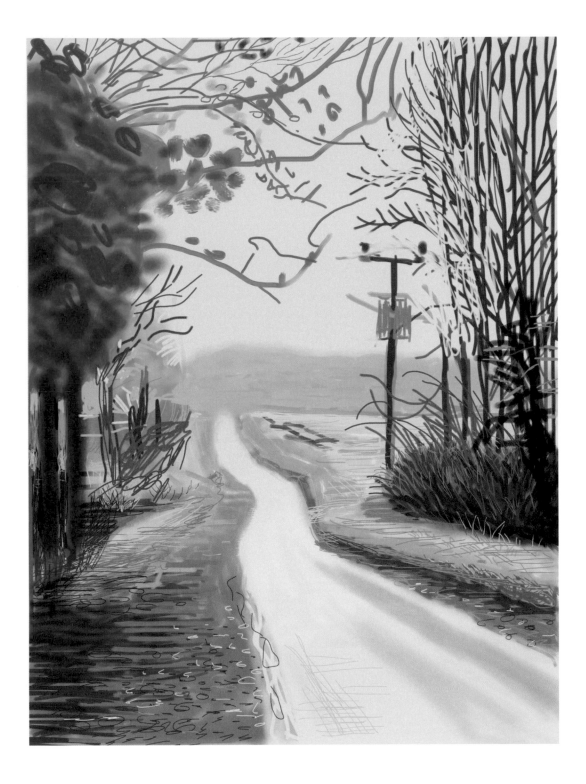

David Hockney
The Arrival of Spring in Woldgate, East Yorkshire
in 2011 (twenty eleven) – 23 February
2011

Prem Sahib
Work That Body Yellow I
2012

*An illustration of Madeleine McCann's eye
was used in the hunt for the missing toddler*

Farrow & Ball
Colour Card

Waitrose
Cooks' Ingredients: Surprisingly Versatile!
Fresh Ginger for Savoury or Sweet

Matthew Darbyshire
Untitled: Furniture Island No. 8
2012

Philips 'hue' customisable lighting scheme
on the National Theatre, London
2007 onwards

Damien Hirst
8-chlorotheophylline
2003

Pablo Bronstein
Prison Block
2014

Anish Kapoor
Orbit
2010

Happy Economics

'Happiness therefore is not a new concept or
discipline; what is new, however, is our ability to measure
happiness in a reliable way and on a large scale.'

We now know more about the people of Britain than ever before. Credit card companies, supermarkets, online businesses and websites like Google collect a vast amount of data on our everyday lives. But in Britain we also know a lot more about something much more important than our food preferences, credit ratings and holiday choices, because we collect more data than any other country on people's happiness. By happiness, I mean the broad concept of an individual's overall quality of life or their wellbeing. This wealth of data has changed the way the public, academics and government policymakers measure and understand social progress in the UK and, for British economists, this data provides a huge new opportunity to improve our understanding of how we make and assess policy.

Many philosophers and most economists take what's known as a 'welfarist' view of the world: the concept that welfare or wellbeing is central to our lives and that there is in fact nothing of greater importance than our wellbeing. Clearly we value lots of things – our health, our family, our children's education, our jobs, the environment – but they are important because ultimately they make us happy. Things like health and education are of 'instrumental value' to us (they are a means to an end), whereas wellbeing is of ultimate 'intrinsic value' (it is the end we strive for). If wellbeing is the intrinsic human good, then happiness data allows us to assess whether what we do is *right* for people and society in a moral sense; we can assess whether as individuals and governments our actions have increased people's wellbeing. And ultimately, with this data, we can make better choices for ourselves and for society.

This is not a new concept. Our interest in happiness can be traced back to the Ancient Greeks. Aristotle and Epicurus, among many others, had passionate views about what a 'good life' consisted of and how we might define happiness. After a period in which the concept of wellbeing took a backseat during the Middle Ages, it re-emerged strongly in Britain in the eighteenth

'Happiness data allows us to assess whether what we do is right for people and society in a moral sense; we can assess whether as individuals and governments our actions have increased people's wellbeing.'

century when Jeremy Bentham first attempted to build a comprehensive and systematic framework for using happiness measures in the formation of government policy. He proposed that governments should aim to maximise people's experiences of pleasure (happiness) over pain. This came to be known as utilitarianism. The inherent problem for this theory was how to measure pleasure and pain in a robust way.

Economists for the past 100 years or so have measured wellbeing in terms of the extent to which one's preferences are satisfied, based on the notion that the more of your wants that are satisfied, the better your life is.[1] This came to be known as 'utility' in economics. The concept makes measurement easier because we can use people's choices to measure their wellbeing. Subsequently, since a higher income usually means that we are able to satisfy more of our wants, income and GDP per capita metrics became, for economists, proxies for an individual's level of wellbeing. This led to the dominance of GDP and national

1 Derek Parfit, *Reasons and Persons* (Oxford: Oxford University Press, 1984)

income measures in public policy discussion in the UK over the past decades, starting, many would argue, during the Thatcher period.

But we are entering a new era. Psychologists and other social scientists have developed ways of measuring and quantifying wellbeing more directly by asking people how they feel, using what are called subjective wellbeing (SWB) questions (questions about an individual's own views about their quality of life). These SWB measures have been validated through extensive psychometric and statistical testing. Interest in SWB measures in economics and in policy making has been spurred on, to a large degree, by this new availability of data and also by a growing literature in behavioural economics (that has been driven mainly by academics in the US and UK) showing that people's preferences and their income can be poor measures of their wellbeing (more on this below). Happiness therefore is not a new concept or discipline; what is new, however, is our ability to measure happiness in a reliable way and on a large scale.

The UK is at the forefront of this global movement. In 2010, Prime Minister David Cameron launched the National Wellbeing Programme to 'start measuring our progress as a country, not just by how our economy is growing, but by how our lives are improving; not just by our standard of living, but by our quality of life.' Every year hundreds of thousands of people in Britain are asked questions about how they are feeling right now and how they feel about their life as a whole. This data is collected through national surveys and, increasingly, online and through smartphone apps. Two of the most common questions in these surveys relate to life satisfaction ('Overall, how satisfied are you with your life nowadays?') and momentary happiness ('How happy do you feel now?'), which are normally answered on scales of 0–10 or 1–7. Admittedly, there are concerns about the extent to which these short questions produce a full picture of a person's quality of life, but these measures have been shown to per-

'In 2010, Prime Minister David Cameron launched the National Wellbeing Programme to "start measuring our progress as a country, not just by how our economy is growing, but by how our lives are improving; not just by our standard of living, but by our quality of life".'

form pretty well. For example, they correlate very strongly with health and suicide rates – two aspects of life that we would intuitively expect to be closely associated with wellbeing – and, in laboratory tests, the responses to these questions also correlate with activity in areas of the brain that are associated with pleasurable experiences and happiness.[2]

The appeal of this SWB data is that it is collected alongside data on a whole host of other life events and circumstances about the individual, which allows us to measure the effects of different events and circumstances on wellbeing. For example, the wellbeing literature shows that employment is good for wellbeing, social relationships are important and health is very important, while pollution and environmental degradation, political corruption and poverty are bad. And this is the big draw for economists because where we have data on policy-relevant outcomes, such as employment, health and education, we can see how these factors (which are often the focus of high levels of public spending)

impact on people's quality of life. More and more economists are using SWB measures – they even have a name: 'Happiness Economists'. And UK universities are, in many respects, leading research in this area with a high number of professional 'Happiness Economists' and a growing number of courses devoted to the subject. In the words of Nobel Laureate Daniel Kahneman, economics is going 'Back to Bentham';[3] that is to say, traditional measures such as GDP are being swapped for the more direct individual-focused measures of wellbeing that Bentham originally proposed.

Britain has a long history of thinking about wellbeing in terms of public policy. Bentham's early work was developed by later utilitarian thinkers such as John Stuart Mill, and in many respects it is fitting that the use of happiness data in policy is being led by the country that first conceptualised the approach. One could argue that the early British utilitarian thinkers helped set out the foundations for Britain becoming the world leader in developing

2 For a summary of the literature
 see Daniel Fujiwara/Ross Campbell,
 *Valuation Techniques for Social
 Cost-Benefit Analysis: Stated
 Preference, Revealed Preference
 and Subjective Well-Being
 Approaches – A Discussion of the
 Current Issues* (Department of
 Works and Pensions: London, 2011)

3 Daniel Kahneman, 'Back to
 Bentham? Explorations of
 Experienced Utility', *The Quarterly
 Journal of Economics*, Vol. 112,
 No. 2, 1997, pp. 375–406

4 Liliana Winkelmann/Rainer
 Winkelmann, 'Why Are the
 Unemployed So Unhappy?
 Evidence from Panel Data',
 Economica, Vol. 65, No. 257, 1998,
 pp. 1–15

5 Stephan Meier/Alois Stutzer, 'Is
 Volunteering Rewarding in Itself?',
 Economica, Vol. 75, No. 297, 2008,
 pp. 39–59

6 R. Metcalfe/Paul Dolan, 'Valuing
 Wind Farms: Does Experience
 Matter?', available at pauldolan.
 co.uk/aluing-wind-farms-does-
 experience-matter.html
 (last visited: 8 December 2014)

7 Daniel Fujiwara/Paul Dolan,
 'Valuing Mental Health', 2014,
 available at psychotherapy.org.
 uk/UKCP_Documents/Reports/
 ValuingMentalHealth_web.pdf
 (last visited: 8 December 2014)

happiness data, the importance of which seems to be recognised across the political spectrum.

There are two key roles and insights that happiness data offers for policy making. Firstly, happiness data sheds new light on what is important in our lives. We miss so much of the detail when we base all of our information on people's choices and income. For example, using a GDP view of the world, the value of employment has traditionally been measured as the gain in income experienced by the individual, and the value of volunteering to society has been calculated as the amount of money that the charity would have had to pay for the labour input had it not been provided on a voluntary basis. But UK happiness data shows that employment has a large impact on people's wellbeing over and above the benefits of receiving a wage[4] (mainly due to self-esteem, a sense of purpose, and the feeling of being a productive member of society). The data also shows that volunteers themselves see improvements in wellbeing (due to growing self-esteem and the warm-glow feeling of altruism).[5] Happiness data shows that employment and volunteering are much more important to people in Britain than we once thought.

As another example, when we just look at choices and preferences, we see, for instance, that people do not want wind farms in their local area and that they consider physical health problems to be much more serious than mental health ones. But happiness data shows that after a short period of time, wind farms in one's local area can actually lead to increases in wellbeing[6] (maybe people felt proud about caring for the environment) and that mental health conditions are far worse for wellbeing than physical health conditions.[7] Part of what explains this is that when we ask people what they want, they underestimate the degree to which they will adapt to things; people adapt to wind farms pretty quickly and come to think they are a good thing, and people also adapt to physical health conditions much better than mental health conditions, whatever the level of severity.

'Happiness data sheds new light on what is important in our lives. We miss so much of the detail when we base all of our information on people's choices and income.'

Happiness data allows us to look at people's actual experiences of different events and circumstances rather than what they think they want or think they will experience, which can be a notoriously poor gauge of their wellbeing.

Secondly, happiness data can be used in a very exciting new way to assign monetary values to non-market outcomes, such as improved health or lower levels of crime using the Wellbeing Valuation approach. One of the key decision-making tools in the UK – as well as other OECD countries – is cost-benefit analysis (CBA). CBA assigns monetary values to the costs and benefits of an intervention so that the overall impact on society can be assessed. According to CBA, the monetary value of a benefit, like reductions in crime, is the amount of money that, if received by the individual, would generate the same positive effect on their wellbeing as that crime reduction. This is possible to estimate from the happiness data if we estimate the impact that income and reductions in crime respectively have on SWB. If the monetised benefits outweigh the costs of the policy we can deduce that social wellbeing has increased due to the intervention and the policy should be undertaken (recall that wellbeing is the ultimate intrinsic good).

This method has been used extensively by a number of UK government departments to place a value on a range of non-market outcomes such as the environment, crime, employment, health, education, sports activities and so on. Interestingly, one area where it has received a lot of attention is in the cultural sector, because this sector has traditionally struggled to value the contribution that culture and the arts make to our lives. To date, this has often been estimated by the amount of GDP that cultural institutions generate through employing people and tourism, but clearly this traditional approach is insufficient as it does not capture the value that we place on having access to and engaging with the arts. Our research in this area has shown, for example, that on average in Britain the value of being

> 'We are making progress in quantifying the benefits and value that the arts in Britain have for us as individuals rather than just for the economy.'

a regular audience member of the arts (e.g. music, dance, theatre, film, exhibitions) is worth about £935 per year to the individual; regularly participating in dance is worth about £1,671 per year; and a single cinema visit about £8.

As with employment, volunteering, wind farms and health, happiness data allows us to assess the relationship between the arts and people's wellbeing at a much deeper level. We are making progress in quantifying the benefits and value that the arts in Britain have for us as individuals rather than just for the economy.

Happiness data and happiness economics offer a huge opportunity for us to improve quality of life in twenty-first century Britain. We may, in many respects, have gone back to Bentham, but in doing so we now have a happier future.

List of Works
Acknowledgements
Biographies and Bibliographies

Measurements are given
in centimetres,
height x width x depth

John Akomfrah

Bruce Beresford (dir.)
*Barbara Hepworth at the Tate.
Filmed during the Barbara
Hepworth retrospective
exhibition at the Tate Gallery,
London, 3rd April 1968–19th
May 1968*, 1968
12 mins
BFI and Arts Council England

Stuart Brisley and Ken
McMullen (dirs.)
Being & Doing, 1984
55 mins
BFI and Arts Council England

John Chesworth, Clive Myer
(dirs.)
Imprint, 1974
46 mins
BFI and Arts Council England

Alnoor Dewshi (dir.)
*Latifah and Himli's
Nomadic Uncle*, 1992
15 mins
BFI and Arts Council England

Steve Dwoskin (dir.)
*Shadows from Light. The
Photography of Bill Brandt*,
1983
59 mins
BFI and Arts Council England

Gilbert & George
*The World of Gilbert and
George*, 1981
69 mins
BFI and Arts Council England

Malcolm Le Grice (dir.)
Whitchurch Down (duration),
1971
8 mins
BFI and Arts Council England

Rodreguez King-Dorset (dir.)
*Winston Silcott. The beard of
justice*, 1994
7 mins
BFI and Arts Council England

The Lacey Family (dirs.)
*The Lacey Rituals. Some of
the rituals, obsessions & habits
of the Lacey Family*, 1973
60 mins
BFI and Arts Council England

Katrina McPherson (dir.)
Pace, 1995
5 mins
BFI and Arts Council England

Nicholas Monro (dir.)
Sailing Through, 1971
5 mins
BFI and Arts Council England

Chris Rodriguez,
Rod Stoneman (dirs.)
*Photomontage Today: Peter
Kennard*, 1982
35 mins
BFI and Arts Council England

James Scott (dir.)
Richard Hamilton, 1969
24 mins
BFI and Arts Council England

David Thompson (dir.)
*Francis Bacon. Paintings
1944–62*, 1963
11 mins
BFI and Arts Council England

Margaret Williams (dir.)
Jeff Keen Films, 1983
36 mins
BFI and Arts Council England

Judith Williamson (dir.)
A Sign is a Fine Investment
1983
44 mins
BFI and Arts Council England

Peter Wyeth (dir.)
12 Views of Kensal House, 1984
55 mins
BFI and Arts Council England

Simon Fujiwara

Atspeed
*Balcoform Platinum Clearview
Walk-On Balcony*, 2014
Mild steel frame; composite
recycled wood effect decking,
toughened and laminated
frameless glass balustrade,
brushed stainless steel handrail
and LED downlights
130 x 200 x 100
Atspeed Balcoform

Brooms, 2011
Borrowed from residents
of Hackney

Clink Restaurant place setting
Courtesy The Clink Charity

Farrow & Ball
Colour Card

Daily Mirror, 5 May 2007

Waitrose
Herbs and spices, 2015

*Main seam coal from Minorca
Surface Mine, Swadlincote*
Courtesy UKCSMR Limited

Nigella Lawson Living Kitchen
Serving Hands

Philips
Philips hue Demonstration Kit,
2015
hue connected lighting
solution, including hue tap
and tablet
Courtesy Philips Lighting

Consolata Boyle
Costume designed for Meryl
Streep in *The Iron Lady*, 2011
Navy dress and jacket with
white edging, pearl necklace,
diamante brooch, black
handbag, court shoes
Courtesy Angels the
Costumiers, London

Pablo Bronstein
Prison Block, 2014
Ink and watercolour on paper
in artist's frame
123 x 116.5 x 4
Jupiter Artland private
collection. Courtesy Herald St,
London

Matthew Darbyshire
*Untitled: Furniture Island
No. 8*, 2012
Eliterank carpet, oversize
Chinese Globe paper lantern,
Branex Tam Tam stools,
Costcutter Arc classroom table,
Jesus figurine, vintage African
carving, acrylic bong,
Nike Air Force 1 trainers
200 x 200 x 200
Courtesy Herald St, London

Ceal Floyer
Garbage Bag, 1996
Garbage bag, air and twist-tie
Dimensions variable
Courtesy the artist and Lisson
Gallery

Simon Fujiwara
*Ephemera from school
performance of Mary Poppins*,
1991
Mixed media
Dimensions variable
Courtesy the artist

Simon Fujiwara
*School performance of
Mary Poppins*, 1991
Video
Three scenes; overall
6 mins, 8 secs
Courtesy the artist

Ryan Gander
Imagineering, 2013
HD Projection, stereo sound
1 min, 8 secs
Courtesy the artist and Lisson
Gallery

Damien Hirst
8-chlorotheophylline, 2003
Household gloss on canvas
43.2 x 58.4
Private collection

David Hockney
*The Arrival of Spring in
Woldgate, East Yorkshire
in 2011 (twenty eleven) –
23 February*, 2011
iPad drawing printed on paper
139.7 x 105.4
Private Collection, courtesy
Annely Juda Fine Art, London

Anish Kapoor
Orbit, 2010
124 x 67.5 x 67.5
Courtesy the artist

Prem Sahib
Work That Body Yellow I, 2012
Anodised aluminium, resin
74 x 54
Southard Reid

Sam Taylor-Johnson
David Beckham ('David'), 2004
Digital video displayed
on plasma screen
64 mins, 7 secs
Artist's proof. Portrait
commissioned by the Trustees
of the National Portrait Gallery
and made possible by J.P.
Morgan through the Fund for
New Commissions, 2004

Gavin Turk
Bag (9), 2001
Painted bronze
60.5 x 57 x 48
The New Art Gallery Walsall

Roger Hiorns

Professor Simon Mead,
MRC Prion Unit, UCL Institute
of Neurology, London
*20 point rating scale used to
measure progression of
the disease, published in the
journal Brain, April 2013*
Courtesy NHS National Prion
Clinic and MRC Prion Unit, UCL
Institute of Neurology, London

*Box of 22 histological
slides showing sections of
mouse brain from mice
infected with scrapie*, 1998
Glass, plastic, paper (fibre
product); brass, plastic
2.9 x 8 x 13
The Science Museum, London

June Bridgeman,
Nicholas Phillips, Malcolm
Ferguson-Smith
The BSE Inquiry: Return to

an order of the Honourable
the House of Commons dated
October 2000 for the report,
evidence and supporting
papers of the inquiry into the
emergence and identification
of bovine spongiform
encephalopathy (BSE) and
variant Creutzfeldt-Jakob
disease (vCJD) and the action
taken in response to it up to
20 March 1996
16 volumes
(The Stationery Office: London,
2000)

Cattle ear tag
Private collection

British Cattle Movement
Service
Cattle Passport
Private collection

Animal Health and Plant
Agency
Clinical Signs of Bovine
Spongiform Encephalopathy
in Cattle, 2013
33 mins
Courtesy Animal Health and
Plant Agency

Roy Anderson
The Epidemic of Mad Cow
Disease (BSE) in the UK, 1997
59 mins
Courtesy The University of
Sheffield with permission of
Kroto Research Inspiration
and the University of Sheffield
VEGA Science Film Archive,
originally produced by the
VEGA Science Trust.

J.W. Ironside
Fax to Dr. Alisa Wight from
Dr J.W. Ironside regarding
neuropathogical studies on
CJD, 13 March 1996
Paper, ink
29.5 x 21
Wellcome Library, London

The first investigation of
vCJD using a western blot to
detect rogue prion proteins
present in the brains of patients,
21 May 1996
Courtesy Professor John
Collinge, MRC Prion Unit, UCL
Institute of Neurology, London

Robert Bygott (dir.)
Kuru: The Science and the
Sorcery. Dedicated to the Fore
and other people who suffered
from the kuru epidemic in
Papua New Guinea, 2010
52 mins
Courtesy Francesca Hope,
Siamese Pty Ltd

Douglas Hogg
Letter from Douglas Hogg
M.P.,14 March 1996, asking the
Spongiform Encephalopathy
Advisory Committee (SEAC) to
submit new advice as soon
as they are able, 14 March 1996
Paper, ink
29.5 x 21
Wellcome Library, London

R.J. Packer
Letter from R.J. Packer
regarding links between
BSE & CJD, 13 March 1996
Paper, ink
29.5 x 21
Wellcome Library, London

Minister of Agriculture John
Selwyn Gummer tries to force
feed a burger to his daughter
to prove British beef is safe;
she refuses so he eats it himself
16 May 1990
15.18 secs
Courtesy BBC Motion Gallery /
Getty Images

'Natural History', from Without
the Walls: The Turner Prize 1995
1995
Excerpt duration: 1 min, 30 secs
Courtesy Channel 4/
Screenocean

Margot McMaster and Darrel
Rowledge (dirs.)
No Accident, 2014
Video
13 mins
Courtesy Margot McMaster

Nicolaus Geyrhalter (dir.)
Our Daily Bread, 2006
92 mins
Courtesy ICA/Park Circus

Ray Young, MRC Prion Unit,
UCL Institute of Neurology
Photograph of a meeting
bringing together foreign
and Papua New Guinean
researchers who had worked
on the disease kuru, including
representatives of the
kuru-affected communities in
the Eastern Highlands of Papua
New Guinea, 11–12 October
2007, Royal Society, London
Courtesy MRC Prion Unit, UCL
Institute of Neurology, London

Richard Newton,
MRC Prion Unit, UCL Institute
of Neurology
Photographs of prototype
blood test for variant
Creutzfeldt-Jakob disease,
published in The Lancet,
February 2011
Courtesy Dr Graham Jackson,

MRC Prion Unit, UCL Institute
of Neurology, London

Prionics Ag Switzerland
Prionics®-Check WESTERN Kit,
Article 12000: Test for in-vitro
detection of TSE-related PrPSc
in cattle
Courtesy Celtic Diagnostics Ltd

PRN100 vial
Courtesy MRC Prion Unit, UCL
Institute of Neurology, London

Thomas Comber
Real Improvements in
Agriculture-on the Principles of
A. Young, Esq;-recommended
to accompany improvements
of rents; in a letter to Reade
Peacock, Esq; ... To which is
added, a Letter to Dr. Hunter ...
concerning the Rickets in Sheep
(W. Nicoll: London, 1772)
Senate House Library,
University of London

House of Commons
The Report from the
Committee, to whom the
petition of several Gentlemen,
Farmers, and of other Persons,
Breeders and Feeders of
Sheep, in the county of Lincoln
was referred
(House of Commons: London,
1755)

Reproductions of archival
material relating to BSE/vCJD
c.1985–96
Wellcome Library, London

Ribbon Representation of
Human Prion Protein, 2014
3D printed model from
x-ray crystallography data,
shown as ribbon structure
representing protein backbone
Plaster based powder
infiltrated with cyanoacrylate
27.2 x 35 x 20.6
Model reference:
PDB ID: 2W9E.
Antonyuk, S.V., Trevitt, C.R.,
Strange, R.W., Jackson, G.S.,
Sangar, D., Batchelor, M.,
Cooper, S., Fraser, C., Jones,
S., Georgiou, T., Khalili-Shirazi,
A., Clarke, A.R., Hasnain, S.S.,
Collinge, J. (2009). Crystal
structure of human prion
protein bound to a therapeutic
antibody. Proc.Natl.Acad.Sci.
USA 106: 2554. Data from
the RCSB Protein Data Bank
(www.rcsb.org). H.M. Berman,
J. Westbrook, Z. Feng, G.
Gilliland, T.N. Bhat, H. Weissig,
I.N. Shindyalov, P.E. Bourne
(2000) The Protein Data
Bank. Nucleic Acids Research,

28: 235-242.
Ribbon structure prepared for
printing from data by Dr Anna
Tanczos, Sci-Comm Studios Ltd

Safety cabinet used at the
Institute for Animal Health
in Edinburgh, 1980s
Steel, glass, rubber, plastic,
electrical components
199 x 127 x 84
The Science Museum, London

Sequential MRI scans of
a human brain displaying
progression of vCJD
Courtesy NHS National Prion
Clinic and MRC Prion Unit, UCL
Institute of Neurology, London

Keith Arnatt
I wonder whether cows
wonder, 2002
22 c41 photographic EN
colour prints mounted on card,
9 selected
Each 10 x 15.1
Arts Council Collection,
Southbank Centre, London

Lygia Clark
Parafuso sem fim, 1963
Aluminium
38.4 x 30.5 x 0.6
Private Collection London

Roger Hiorns
Untitled, 2008
Steel, brain matter
63 x 63 x 4
Courtesy Corvi-Mora, London

Damien Hirst
Out of Sight. Out of Mind., 1991
Glass, painted steel, silicone,
cows' heads and formaldehyde
solution
Two parts, each
45.7 x 83.8 x 45.7
Private Collection

Charles Jones
Sheep, 1875
Oil on canvas
86 x 112
The New Art Gallery Walsall

Ali Kayley
Poor Cow, 1994
Plastic
89.2 x 25.1
Arts Council Collection,
Southbank Centre, London

William Kidd
Death of Poor Mailie,
c.1833–55
Oil on canvas
25 x 20.2
On loan Dundee City Council
(Dundee's Art Galleries and
Museums)

Jørgen Leth and Ole John
(dirs.)
'My Name is Andy Warhol'
from 66 Scenes from America
(66 scener fra America), 1982
Video
4 mins, 12 secs
Courtesy the artists and
Andersen's Contemporary,
Copenhagen

Gustav Metzger
Mad Cows Talk, 1996 (partial
reconstruction 2015)
Audio lecture and slides
Courtesy the artist

Laurène Pijulet-Balmer
Under Your Skin: Creutzfeldt-
Jakob, 2013–14
Black ink and colour pencil
on paper
42 x 29.7
Courtesy the artist

Tony Ray-Jones
Picnic, Glyndebourne 1967,
1967
Silver bromide print
17.8 x 26.8
Arts Council Collection,
Southbank Centre, London

Thomas Weaver (artist and
publisher); William Ward
(engraver)
Portrait of Thomas William
Coke, 1808
Engraving (mezzotint)
55.5 x 72
Museum of English Rural Life,
University of Reading

Thomas Weaver (artist and
publisher); William Ward
(engraver)
The Newbus Ox, 1812
Engraving (mezzotint)
45.2 x 60.2
Museum of English Rural Life,
University of Reading

Hannah Starkey

Brian Alterio
(Man on edge of pier), 1977–78
Gelatin silver print
16.5 x 25.5
Arts Council Collection,
Southbank Centre, London

Brian Alterio
(Woman across river from
man), 1976–78
Gelatin silver print
16.5 x 25.5
Arts Council Collection,
Southbank Centre, London

Jonathan Bayer
Untitled (Gear for cell in
punishment block, Everthorpe
Borstal), 1977
Selenium-toned silver
bromide print
20.5 x 13.3
Arts Council Collection,
Southbank Centre, London

John Benton-Harris
Ascot Races, July 1973, 1973
Gelatin silver print
20.5 x 32
Arts Council Collection,
Southbank Centre, London

John Benton-Harris
Eton Parents Day June 1976,
1976
Gelatin silver print
32 x 21
Arts Council Collection,
Southbank Centre, London

John Benton-Harris
Richmond, Surrey 1974, 1974
Gelatin silver print
20.5 x 31
Arts Council Collection,
Southbank Centre, London

John Benton-Harris
Strangers on a train (SR–BR)
1979, 1979
Gelatin silver print
20.5 x 31
Arts Council Collection,
Southbank Centre, London

Jane Bown
Samuel Beckett, 1976
Silver bromide print
22.9 x 34.1
Arts Council Collection,
Southbank Centre, London

Victor Burgin
Possession, 1976
Photo-lithographic print
120 x 84
Arts Council Collection,
Southbank Centre, London

Ron Burton
'Oh Deirdre, that nasty ball!',
1970
Gelatin silver print
23.5 x 33
Arts Council Collection,
Southbank Centre, London

David Chadwick
A Woman on a Hulme Walkway,
Manchester, 1976
Gelatin silver print
17.9 x 27.6
Arts Council Collection,
Southbank Centre, London

Ian Dobbie
Dogs on Wasteland, 1972

Silver bromide print
19.5 x 12.8
Arts Council Collection,
Southbank Centre, London

Kent Gavin
Price of a sealskin coat, 1968
Gelatin silver print
29.3 x 25
Arts Council Collection,
Southbank Centre, London

Paul Graham
Baby and interview cubicles,
Brixton DHSS, South London,
1984, 1985
C-type colour print
28 x 35.5
Arts Council Collection,
Southbank Centre, London

Brian Griffin
Marshall McCluhan –
Philosopher, 1978, 1979
Gelatin silver print
43.2 x 28.9
Arts Council Collection,
Southbank Centre, London

Brian Griffin
Untitled – Liverpool, 1979, 1979
Gelatin silver print
43.3 x 28.6
Arts Council Collection,
Southbank Centre, London

The Hackney Flashers
Who's Holding the Baby?, 1987
Twenty-nine 35mm slides
Arts Council Collection,
Southbank Centre, London

Paul Hill
Josephine, Nottingham, 1974
Silver print
30.3 x 20.1
Arts Council Collection,
Southbank Centre, London

Paul Hill
Man against snow, Austria,
1974
Silver print
39.2 x 30.2
Arts Council Collection,
Southbank Centre, London

John Hilliard
Cause of Death, 1974
Black & white photographs &
text on card, 4 sections
Each photograph 28.5 x 14.5
Arts Council Collection,
Southbank Centre, London

Hipgnosis
Untitled, 1976
Colour photograph
37.6 x 36.8
Arts Council Collection,
Southbank Centre, London

Hipgnosis
Winkies, 1975
Colour photograph
29 x 49.2
Arts Council Collection,
Southbank Centre, London

David Hurn
Barry Island, Wales, 1971–81
Gelatin silver print
25 x 37.5
Arts Council Collection,
Southbank Centre, London

David Hurn
Untitled, 1971–81
Gelatin silver
37.5 x 25
Arts Council Collection,
Southbank Centre, London

David Hurn
Untitled, 1971–81
Gelatin silver print
25 x 37.5
Arts Council Collection,
Southbank Centre, London

Donald Jackson
Twisted trees, Via Gellia,
Derbyshire, 1977
Gelatin silver print
20.2 x 18
Arts Council Collection,
Southbank Centre, London

Steve Johnston
City Portrait, 1977–78
Silver bromide print
29.2 x 20
Arts Council Collection,
Southbank Centre, London

Steve Johnston
Punk Portrait, 1977–78
Silver bromide print
29 x 19
Arts Council Collection,
Southbank Centre, London

Colin Jones
Untitled (Man) (Black House),
1976
Silver bromide print
30.3 x 20.1
Arts Council Collection,
Southbank Centre, London

Chris Killip
Miss Susan Hyslop, Ballachink,
St Marks, 1970–73
Gelatin silver print
18.6 x 14.5
Arts Council Collection,
Southbank Centre, London

Chris Killip
Mrs Hyslop, the Braid, 1970–73
Gelatin silver print
18.9 x 14.7
Arts Council Collection,
Southbank Centre, London

Chris Killip
South Bank, Middsboro, 1975
Silver bromide print
19.7 x 25.5
Arts Council Collection,
Southbank Centre, London

Chris Killip
Youth, Jarrow, 1976
Silver bromide print
19.7 x 25.5
Arts Council Collection,
Southbank Centre, London

William Lovelace
Bayoneting in Bangladesh, 1972
Silver bromide print
29.2 x 36.8
Arts Council Collection,
Southbank Centre, London

Marketa Luskacova
*Portobello Rd. Market, London,
1975 (From the series 'London
Street Markets'),* 1974
Silver bromide print
24 x 16
Arts Council Collection,
Southbank Centre, London

Marketa Luskacova
*Sleeping Pilgrim, Levoca,
Slovakia, 1968 (From the series
'Pilgrims'),* 1968
Silver print
20 x 28.5
Arts Council Collection,
Southbank Centre, London

Melanie Manchot
Mrs Manchot, Arms Overhead,
1996
Silver gelatin print and mixed
media on canvas
193 x 140
Arts Council Collection,
Southbank Centre, London

Ron McCormick
Mile End Hospital, London 1974,
1974
Gelatin silver print
21 x 32
Arts Council Collection,
Southbank Centre, London

Ron McCormick
Sheffield 1976, 1976
Gelatin silver print
21.2 x 31.5
Arts Council Collection,
Southbank Centre, London

Ron McCormick
*Wentworth Street, Whitechapel
1970–72*
Silver bromide print
16.9 x 25.4
Arts Council Collection,
Southbank Centre, London

David Montgomery
Untitled (Gallery), 1976
Kodachrome print
27.1 x 43.3
Arts Council Collection,
Southbank Centre, London

Hayley Newman
Stealth, 1998
Black and white photograph
55 x 106
Arts Council Collection,
Southbank Centre, London

Hayley Newman
You Blew My Mind, 1998
Black and white photograph
mounted on aluminium
92.5 x 91
Arts Council Collection,
Southbank Centre, London

Sue Packer
Brian Young (from 'Tintern
Portraits', series of 51 portraits),
1983
Silver print
25.2 x 25.4
Arts Council Collection,
Southbank Centre, London

Sue Packer
Sarah Horton (from 'Tintern
Portraits', series of 51 portraits),
1984
Silver print
25.2 x 25.4
Arts Council Collection,
Southbank Centre, London

Martin Parr
Bournemouth 1978, 1978
Gelatin silver print
16 x 24.2
Arts Council Collection,
Southbank Centre, London

Helen Robertson
Navel, 1994
Black and white photograph
mounted on aluminium
177 x 138
Arts Council Collection,
Southbank Centre, London

Homer Sykes
*Whit Wednesday Pinner Fair,
Pinner, Middlesex, 1969–75*
Silver bromide print
22.2 x 33
Arts Council Collection,
Southbank Centre, London

Mitra Tabrizian
*Untitled Part 12 in series -
"College of Fashion/Modelling
Course",* 1981
Silver print
39.5 x 29
Arts Council Collection,
Southbank Centre, London

Wolfgang Tillmans
Dan, 2008
C-type print
40 x 30
Arts Council Collection,
Southbank Centre, London
Purchased with the assistance
of the Art Fund. Partial gift of
the artist and Maureen Paley,
London

Paul Trevor
*Haigh Heights, Haigh Street,
Everton, Liverpool,* 1975
Gelatin silver print
36 x 24
Arts Council Collection,
Southbank Centre, London

Christine Voge
Crying Child, 1978
Gelatin silver print
29.7 x 20.1
Arts Council Collection,
Southbank Centre, London

Patrick Ward
*Untitled (Soldiers marching
behind woman),* 1977
Gelatin silver print
22.6 x 33.5
Arts Council Collection,
Southbank Centre, London

Valerie Wilmer
Untitled, 1972–78
Gelatin silver print
20 x 42.7
Arts Council Collection,
Southbank Centre, London

Jack Yates
Girl Undressing, 1972
Gelatin silver print
17.5 x 11.7
Arts Council Collection,
Southbank Centre, London

Bettina von Zwehl
No.6 from Profiles III, 2005–06
C-type print
155.6 x 125.2
Arts Council Collection,
Southbank Centre, London

Richard Wentworth

38 stones and pebbles in
wooden crate, from Henry
Moore's Maquette Studio,
Perry Green
The Henry Moore Foundation

Unknown photographer
Air-conditioned bed shown in
the Designers Look Ahead
section of *Britain Can Make It,*
1946
Black and white photographic
print
15.5 x 21.2

Design Council / University
of Brighton Design Archives

Design Research Unit with
Council of Industrial
Design
'Birth of an Egg Cup' (dummy)
booklet, 1946
Machine-made paper booklet
with six pages, stapled
24.7 x 18.5
Design Council / University
of Brighton Design Archives

Unknown photographer
Birth of an egg cup in the
'What Industrial Design Means'
section of *Britain Can Make It,*
1946
Black and white photographic
print mounted on card
20.4 x 15
Design Council / University of
Brighton Design Archives

War Office
*Briefing model - Part of Juno &
Sword Beaches (D-Day) One
section of the model depicting
the (coastal) area centred on
Langrune-sur-Mer,* 1944
Cardboard, textile, metal, wood
59 x 59
IWM (Imperial War Museums)

Ferranti International plc
*British Aircraft Corporation
Bloodhound Mark 2 Surface-
to-Air Missile and Launcher,
Guided Missile, Type 202,*
c.1965–66
Aluminium, magnesium
alloy, stainless steel, wood,
resin embossed fabric;
launcher: steel
RAF Air Defence Radar Museum

*Design 46: A Survey of British
Industrial Design as Displayed
in the Britain Can Make It
Exhibition,* 1946
Printed leaflet
Victoria and Albert Museum

Crown Merton
Double saucepan, c.1960s
Aluminium
15 x 33.5 x 23

Guide's metal badge and
cardboard disc tag from the
Britain Can Make It exhibition,
1946
Disc tag 5.4 dia.; badge 3 dia.
Victoria and Albert Museum

British Pathé
*King opens Britain Can Make It
exhibition,* 1946
Video recording
7 mins, 16 secs
Courtesy British Pathé

Unknown photographer
Part of the background in
the War to Peace section of
Britain Can Make It which
shows bomb-scarred London
with a part of a plane in the
foreground, 1946
Black and white photographic
print
16.7 x 21.4
Design Council / University of
Brighton Design Archives

Picture Post magazine,
19 August 1944
London: Hulton Press

Unknown photographer
Prototype electric bicycle
shown in the Designers
Look Ahead section of Britain
Can Make It, 1946
Black and white photographic
print mounted on card
13.5 x 18.9
Design Council / University of
Brighton Design Archives

Pye Ltd
Pye V4 Black and White
Television Receiver, 1953
Wood; wood veneer;
glass; cardboard; electronic
components; plastic
40.5 x 34.5 x 47
The National Media Museum,
Bradford

Reproductions of documents,
photographs and printed
materials relating to the
post-war period
Archive of Modern Conflict

Typed list of items 'War to
Peace' as staged in the Britain
Can Make It exhibition, 1946
Victoria and Albert Museum

Typed sheet showing total
visitor figures to the Britain
Can Make It exhibition, 1946
Victoria and Albert Museum

Ashley Havinden; Haycock
Press Ltd (printers)
Britain Can Make It, 1946
Colour lithography
73.5 x 48.9
Victoria and Albert Museum

John Bratby
Still Life with Chip Frier, 1954
Oil paint on hardboard
131.4 x 92.1
Tate: Presented by the
Contemporary Art Society
1956

Reg Butler
Working Model for 'The
Unknown Political Prisoner',

1955–56
Steel and bronze on plaster
base
223.8 x 87.9 x 85.4
Tate: Presented by Cortina and
Creon Butler 1979

Robert Capa
American soldiers landing on
Omaha Beach, D-Day,
Normandy, France, June 6, 1944
Gelatin silver print
40.6 x 50.8
Courtesy Robert Capa /
Magnum Photos

Robert Capa
American soldiers landing on
Omaha Beach, D-Day,
Normandy, France, June 6, 1944
Gelatin silver print
40.6 x 50.8
Courtesy Robert Capa /
Magnum Photos

Robert Capa
American soldiers landing on
Omaha Beach, D-Day,
Normandy, France, June 6, 1944
Gelatin silver print
27.9 x 35.6
Courtesy Robert Capa /
Magnum Photos

Tony Cragg
Britain Seen from the North,
1981
Plastic, wood, rubber, paper
and other materials
440 x 800 x 10
Tate: Purchased 1982

Henry Grant
Londoners relax on Tower
Beach, 1952
Reprint of original
photographic negative
25 x 25
Museum of London Henry
Grant Collection

Richard Hamilton
Bathers, 1967
Screenprint
70.3 x 94.3
Arts Council Collection,
Southbank Centre, London

Bert Hardy
'A foothold in Hades'. Men of
the US First Marine Division
land on the sea wall, 1950
Silver bromide print
30 x 44.8
Arts Council Collection,
Southbank Centre, London

Bert Hardy
A student nurse feeds a child
recovering from a mastoid
operation, 1953
Silver bromide print

25 x 32
Arts Council Collection,
Southbank Centre, London

Bert Hardy
At a Liverpool street corner,
1949
Silver bromide print
31.8 x 22
Arts Council Collection,
Southbank Centre, London

Bert Hardy
Cleaners inside the War
Office, 1940
Silver bromide print
22.7 x 31.7
Arts Council Collection,
Southbank Centre, London

Bert Hardy
The morning after 'The Biggest
Raid Ever'. A London ARP
Officer has set up his office
in the street, 1941
Silver bromide print
20.8 x 31.8
Arts Council Collection,
Southbank Centre, London

Bert Hardy
Overcrowding in Liverpool. Mrs
Johnson in the bedroom shared
with six grandchildren, 1949
Silver bromide print
22 x 31.8
Arts Council Collection,
Southbank Centre, London

Bert Hardy
Sunday morning in the
Elephant & Castle, Southwark
1949, 1949
Silver bromide print
44.5 x 30
Arts Council Collection,
Southbank Centre, London

Bert Hardy
Work as usual at a Stepney
clothier's the morning
after a bombing attack, 1940
Silver bromide print
22.5 x 31.8
Arts Council Collection,
Southbank Centre, London

Ashley Havinden
Printed diagram showing
main circulation for the Britain
Can Make It exhibition, 1946
27 x 38
Victoria and Albert Museum

Nigel Henderson
Head of a Man, 1956–61
Oil and photographic processes
on card
152.4 x 121.9
Arts Council Collection,
Southbank Centre, London

Barbara Hepworth
Hand II (horizontal), 1949–50
Bronze
10.5 x 31.8 x 21; base:
5 x 30.5 x 22
Private Collection

Barbara Hepworth
Quartet (Arthroplasty), 1948
Oil and pencil on board
59.6 x 50
Trustees of The Cecil Higgins
Art Gallery, Bedford

Barbara Hepworth
Reconstruction (Hospital
Drawing), 1947
Oil and pencil on board
34.3 x 46.4
Arts Council Collection,
Southbank Centre, London

David Hockney
Going to be a Queen
for Tonight, 1960
Oil on board
120 x 85
Royal College of Art Collection

L.S. Lowry
July, the Seaside, 1943
Oil on canvas
66.7 x 92.7
Arts Council Collection,
Southbank Centre, London

Henry Moore
Helmet Head No. 1, 1950
Bronze
33 x 24 x 21
Trustees of The Cecil Higgins
Art Gallery, Bedford

Henry Moore
Maquette for Atom Piece, 1964,
cast Fiorini, London, 1970
Bronze
16.2 x 13.3 x 13.3
The Henry Moore Foundation:
Gift of the artist 1977

Henry Moore
Maquette for Mother and Child,
1938
Plaster
11 x 8 x 6; base: 7.4 x 11.1 x 7.4
Leeds Museums and Galleries
(Leeds Art Gallery)

Henry Moore
Maquette for Stringed
Reclining Figure, 1939
Plaster with stringing and pencil
10 x 30 x 8
Leeds Museums and Galleries
(Leeds Art Gallery)

Henry Moore
September 3rd, 1939, 1939
Pencil, wax crayon, chalk,
watercolour, pen and
ink on heavyweight wove

30.6 x 39.8
The Henry Moore Family
Collection

Henry Moore
Stringed Figure, 1938
Bronze
20.5 x 35 x 30
The Henry Moore Family
Collection

Henry Moore
Stringed Figure, 1939
Bronze and thread
14.5 x 29.3 x 11.5
Leeds Museums and Galleries
(Leeds Art Gallery)

Paul Nash
Battle of Britain, 1941
Oil on canvas
122.6 x 183.5
IWM (Imperial War Museums)

Paul Nash
Totes Meer (Dead Sea), 1940–41
Oil paint on canvas
101.6 x 152.4
Tate: Presented by the War
Artists Advisory Committee
1946

Ben Nicholson,
Festival of Britain Mural, 1951
3 parts on hardboard, oil paint
Overall 216.5 x 487.1 x 48
Tate: Presented by the Court of
the University of Edinburgh
1995

Ben Nicholson
November 11–47 (Mousehole),
1947
Oil on canvas mounted on wood
46.5 x 58.5
British Council Collection

Eduardo Paolozzi
Selection of prints from Bunk,
1972 (original collages 1947–52):
3. Fun Helped Them Fight
7. Take-off
8a. Hazards include Dust,
Hailstones and Bullets. 8b.
Survival
10. Meet the People
11. Improved Beans
14. Goering with Wings
16. Fantastic Weapons
Contrived
33. It's a Psychological Fact
Pleasure Helps Your Disposition
Screenprints and lithographs
on paper
Various dimensions
Courtesy Hayward Touring

Eduardo Paolozzi
The Frog, 1958
Bronze
68.6 x 81.3 x 86.2
Arts Council Collection,
Southbank Centre, London

Eduardo Paolozzi
The History of Nothing, 1963
Film, 16mm transferred
to DVD, black and white
12 mins
Lent by The Paolozzi
Foundation, courtesy BFI

Eric Ravilious
Convoy in Port, 1941
Pencil and watercolour
on paper
50.9 x 55.2
Manchester City Galleries

Jane and Louise Wilson

Large-scale reproduction
from unknown photographer
Camp, Fence and Bailiffs,
c.1987–2000
Photograph
Original photograph courtesy
LSE Library Collections

Large-scale reproduction
from unknown photographer
Camp, Fence and Bailiffs,
c.1987–2000
Photograph
Original photograph courtesy
LSE Library Collections

Large-scale reproduction
from unknown photographer
Lyn Barlow and two other
women breaking through the
fence at Greenham Common,
1980s
Photograph
Original photograph courtesy
LSE Library Collections

Selected reproductions from
Lyn Barlow
Greenham Common Journal,
1984–89
30.2 x 21
Original material courtesy LSE
Library Collections

Large-scale reproduction
from unknown photographer
Lyn Barlow and two other
women breaking through the
fence at Greenham Common,
1980s
Photograph
Original photograph courtesy
LSE Library Collections

Stuart Brisley
Personal View of Some Aspects
of the Peterlee Project (January
1 1976– August 31 1977)
Tate Archive TGA
20042/1/3/45/7
3 sheets

Research photograph for
Stanley Kubrick's unfinished
film Aryan Papers, c.1939–59
Courtesy of the University of
the Arts London Archives and
Special Collections Centre

Artist Project Peterlee
Second Peterlee Report,
c.1973–78
Tate Archive TGA
20042/1/3/45/13
Printed leaflet

Suggested Departments for
the APG Placement Approach
c.1973–78
Tate Archive TGA
20042/1/3/45/6
1 sheet

Conrad Atkinson
Northern Ireland 1968 –
May Day 1975, 1975–76
126 photographs, colour on
paper and typewritten paper
mounted onto board
Overall display dimensions
variable
Tate: Purchased 2010

Christine Borland
Blanket Used on Police Firing
Range, Berlin: Repaired, 1993
Wool
182.9 x 142.2
Arts Council Collection,
Southbank Centre, London

Brass Brassett
Protester being dragged
away by two police officers,
8 March 1983
Photographic print
18 x 12.5
LSE Library Collections

Stuart Brisley
1=66,666 (March 1983 –
Georgiana Collection VI), 1983
Wood, steel, plaster, leather,
nylon, cloth and paper
217 x 500 x 81
Arts Council Collection,
Southbank Centre, London

Stuart Brisley
Beneath Dignity, 1977
23 photographs, black and
white, on paper on card
Each 42.5 x 54.6
Tate: Purchased 1981

Rita Donagh
Belfast boy, 1973
Oil and photograph on canvas
25.5 x 50.5
Courtesy the artist

Rita Donagh
Single cell block, 1984
Oil on photograph on card
50.7 x 60.7
Courtesy the artist

Rita Donagh
'Slade', 1979–80
Etching and photogravure
56 x 72
Courtesy the artist

Richard Hamilton, Jim Dine,
Dieter Roth
Greenham Common print
portfolio, 1984
Printed by Aldo Crommelynck
at Atelier Crommelynck, Paris
Courtesy Alan Cristea
Gallery and the Estate of
Richard Hamilton

1. Richard Hamilton
Mother and Child, 1984
Acrylic and drypoint on
Rives BFK paper
17.5 x 17.5

2. Jim Dine
Hiroshima Clock, First Version,
1984
Soft ground etching and
electric tools on copper plate
Printed in white with hand
applied grey acrylic on Rives
BFK paper
26.6 x 20.7

3. Dieter Roth
Untitled, 1984
Etching and Aquatint on
Rives BFK paper
28.5 x 38.2

Richard Hamilton
The state, 1993
Oil paint, enamel paint
and fabric on cibachrome on
2 canvases
Each canvas 200 x 100
Tate: Purchased 1993

Mona Hatoum
Measures of Distance, 1988
Betacam SP video
15 mins, 26 secs
Arts Council Collection,
Southbank Centre, London

Lucia Nogueira
Binocular, 1996
Mixed media
Dimensions variable
Arts Council Collection,
Southbank Centre, London

Victor Pasmore
*Construction in Black, White
and Ochre*, 1961
Mixed media, perspex, wood
55.8 x 55.8
Collection of mima,
Middlesbrough Institute
of Modern Art

Victor Pasmore
*Model based on designs for
a South West 5 Pavilion,
Peterlee (unbuilt)*, 1968–69;
model printed 2014
ZPrint 3D print with
perspex base
9.8 x 49.5 x 27.5
Apollo Pavilion Community
Association and The School
of Architecture, Planning
and Landscape, Newcastle
University

Victor Pasmore
*Model for Apollo Pavilion,
Peterlee*, c.1967
Wood
12 x 58 x 22
Durham County Council

Victor Pasmore
*What is the Object over There?
Points of Contact No. 17*, 1973
Screenprint on paper
76.5 x 288.9
Tate: Presented by Rose and
Chris Prater through the
Institute of Contemporary
Prints 1975

Toby Paterson
Rotterdam Relief, 2005
Acrylic paint and perspex
100 x 100 x 1
Arts Council Collection,
Southbank Centre, London

Colin Self
*Guard Dog on a Missile Base,
No. 4*, 1966
Newspaper frottage and pencil
45.6 x 75
IWM (Imperial War Museums)

Penelope Slinger
A Difficult Position, 1977
Collage
35 x 50
The artist / Riflemaker, London

Penelope Slinger
Atlantis, 1977
Collage
35 x 50
The artist / Riflemaker, London

Penelope Slinger
Corpus, 1977
Collage
50 x 35
The artist / Riflemaker, London

Penelope Slinger
The End of the Line, 1977
Collage
35 x 50
The artist / Riflemaker, London

Penelope Slinger
Hang-up, 1977
Collage
50 x 35
The artist / Riflemaker, London

Penelope Slinger
Lilford Hall, 1969
16mm black and white and
colour/silent film transferred
to digital video
74 mins, 53 secs
Courtesy of the artist and
Blum & Poe, Los Angeles

Penelope Slinger
Perspective, 1977
Collage
47 x 31
The artist / Riflemaker, London

Penelope Slinger
Self-Image, 1977
Collage
35 x 50
The artist / Riflemaker, London

Christine Voge
Untitled, 1978
Gelatin silver print
19.9 x 29.6
Arts Council Collection,
Southbank Centre, London

Christine Voge,
Untitled, 1978
Gelatin silver print
29.5 x 20
Arts Council Collection,
Southbank Centre, London

Christine Voge,
Untitled, 1978
Gelatin silver print
22 x 29.8
Arts Council Collection,
Southbank Centre, London

Christine Voge,
Untitled, 1978
Gelatin silver print
29.7 x 20.1
Arts Council Collection,
Southbank Centre, London

Christine Voge,
Untitled (Girl), 1978
Gelatin silver print
19.8 x 29.7
Arts Council Collection,
Southbank Centre, London

Christine Voge,
*Untitled (Three children
and woman)*, 1978
Gelatin silver print

29.8 x 20.3
Arts Council Collection,
Southbank Centre, London

Christine Voge
Untitled (Woman), 1978
Gelatin silver print
29.3 x 20.1
Arts Council Collection,
Southbank Centre, London

Jane and Louise Wilson
'Blind Landing' Lab I, 2012
Cast aluminium and
enamel paint
Dimensions variable
Courtesy the artists

Jane and Louise Wilson
'Blind Landing' Lab 4, 2012
Cast aluminium and
enamel paint
Dimensions variable
Courtesy the artists

List of Lenders

The following individuals and
institutions have kindly lent to
the exhibition:

Alan Cristea Gallery
Andersen's Contemporary,
 Copenhagen
Angels the Costumiers, London
Animal Health and Plant
 Agency
Annely Juda Fine Art, London
Apollo Pavilion Community
 Association
Archive of Modern Conflict
Arts Council Collection,
 Southbank Centre, London
Arts Council England
Atspeed
BBC Motion Gallery
Blum & Poe, Los Angeles
British Council Collection
BFI
British Pathé
Celtic Diagnostics Limited
Channel 4 / Screenocean
Corvi-Mora, London
Design Council / University of
 Brighton Design Archives
Rita Donagh
Dundee City Council
 (Dundee's Art Galleries and
 Museums)
Durham County Council
Estate of Richard Hamilton
Ceal Floyer
Simon Fujiwara
Ryan Gander
Getty Images
Hayward Touring
Herald St, London
Francesca Hope
ICA
IWM (Imperial War Museums)

Jupiter Artland private
 collection
Ole John
Sir Anish Kapoor
Jørgen Leth
Leeds Museums and Galleries
 (Leeds Art Gallery)
Lisson Gallery
LSE Library Collections
Magnum Photos
Manchester City Galleries
Margot McMaster
Gustav Metzger
mima, Middlesbrough Institute
 of Modern Art
MRC Prion Unit, UCL Institute
 of Neurology, London
Museum of English Rural Life,
 University of Reading
Museum of London
NHS National Prion Clinic
Park Circus
Philips Lighting
Laurène Pijulet-Balmer
RAF Air Defence Radar
 Museum
Riflemaker, London
Royal College of Art Collection
Senate House Library,
 University of London
Penelope Slinger
Southard Reid
Tate
The Clink Charity
The Henry Moore Family
 Collection
The Henry Moore Foundation
The National Media Museum,
 Bradford
The New Art Gallery Walsall
The Paolozzi Foundation
The School of Architecture,
 Planning and Landscape,
 Newcastle University
The Science Museum, London
The University of Sheffield
Trustees of The Cecil Higgins
 Art Gallery, Bedford
UKCSMR Ltd.
University of the Arts London
 Archives and Special
 Collections Centre
Victoria and Albert Museum
Wellcome Library, London
Richard Wentworth
White Cube
Jane and Louise Wilson

Together with those lenders
who wish to remain
anonymous.

History Is Now: 7 Artists Take On Britain is generously supported by Tony Elliott, Lisson Gallery, Maureen Paley, London, Tanya Bonakdar Gallery, New York, The Henry Moore Foundation and the Wellcome Trust.

Hayward Gallery is immensely grateful for all the help we have received in organising this exhibition, and would like to thank the following individuals, organisations, institutional staff members and studios of the participating artists for their invaluable guidance and assistance.

Lyn Barlow
Maria Bartau Madariaga
Briony Benge-Abbott, Library Exhibition
 Liaison, Wellcome Library
Violetta Boxill, Creative Director,
 Alexander Boxill
Matthew Boyer, Boyer's Body Centre
Consolata Boyle
Andrew Calver, Care Project Manager,
 Department of Collections
 Management, Imperial War Museum
Dr Angela Cassidy, Wellcome Trust Research
 Fellow, King's College London
Professor John Collinge, Director,
 MRC Prion Unit, UCL Institute of
 Neurology, London
Frank Cooper, MRC Prion Unit, UCL Institute
 of Neurology, London
Jane Crane, Trustee, RAF Air Defence Radar
 Museum
Leanne Dmyterko
Gilly Fox, Assistant Curator, Hayward
 Touring
Maria Gafarova, Archive of Modern Conflict
Jane Giles, Head of Content, BFI
Lina Gopaul, Smoking Dogs Films
Holly Grange, Collection and Exhibitions
 Assistant, The Hepworth Wakefield
Stuart Heaney, Rights and Contracts Officer,
 BFI
Sarah Howgate, Contemporary Curator,
 National Portrait Gallery
Jerry Hughes, Foundry Manager, AB Fine
 Art Foundry
Sarvia Jasso, Associate Director, Blum & Poe,
 Los Angeles
Ed Jones, Archive of Modern Conflict
Debbie Lamming, Head of Production &
 Exhibitions, Science Ltd
Lesley McIntyre
Professor Simon Mead, MRC Prion Unit, UCL
 Institute of Neurology, London
Mary Moore
William Morgan, Trustee, Bristol Aero
 Collection Trust
Chris Morshead
John Pasmore
Toby Paterson
Colin Robson, Arts Officer, Durham County
 Council
Ben Russell, Curator of Mechanical
 Engineering, Science Museum
Tom Saunders
Sir Michael Savory, Muckleburgh Collection
Paul Sims, SMR Plant Services Ltd.
Dr Anna Tanczos, Sci-Comm Studios Ltd.
David Taylor-Gooby, Chair, Apollo Pavilion
 Community Association
Tot Taylor, Riflemaker
Sam Taylor-Johnson
Ian Thirsk, Head of Collections, Royal Air
 Force Museum London
Yan Tomaszewski
Richard Vernon
Professor Lawrence Weaver
Dr Abigail Woods, Reader in the History
 of Human and Animal Health, King's
 College London
Steve Woolford, Head of Interpretation and
 Collections, IWM Duxford

At Hayward Gallery and Southbank Centre for their contributions to the realisation of *History Is Now: 7 Artists Take On Britain*, thanks are given to: Diana Adell, Press and Marketing Coordinator, Hayward Publishing; Grace Beaumont, Hayward Administrator; Lucy Biddle, Interpretation Manager; Alison Bowyer, Head of Grants and Trusts Marcia Ceppo, Operations Coordinator; Lorraine Cheesmur, Visitor Experience Manager; Clare Connor, Business Development Director; Dominik Czechowski, Assistant Curator; Melford Deane, Company Secretary and Legal Adviser; Helen Faulkner, Marketing Manager; Ben Fergusson, Art Publisher, Hayward Publishing; Matt Freeman, Patrons Manager; Catherine Gaffney, Staff Editor, Hayward Publishing; Jeanne Gargam, Development Services Administrator; Alex Glen, Publication Sales Officer, Hayward Publishing; Rahila Haque, Assistant Curator; Matthew Holt, Head of Corporate Development; Rukhsana Jahangir, PA to the Director; Nicola Jeffs, Press Manager; Lisa-Marie Lewis, Website Manager; Rohini Malik Okon, Participation Producer; Alison Maun, Bookings and Transport Administrator; Sue McCarthy, Visitor Experience Manager; Filipa Mendes, Press Officer; Hannah Morrison, Grants and Trusts Officer; Nicola Muir, Marketing Officer; Joanna Newell, Patrons Manager; Khadeen O'Donnell, Corporate Development Manager; Clare Rees-Hales, Visitor Experience Ticketing Host; Katie Roberts, Producer; Sarah Ross, Buying and Merchandising Manager; James Runcie, Head of Literature; Eddy Smith, Technical Director; Adam Thow, Head of Retail and Buying; Sarah Toplis, Digital Producer; Charu Vallabhbhai, Assistant Curator; Henry Ward, Head of Education; Hilton Wells, Head of Technical Services (Estates and Facilities); Fergus Wright, Interim Health and Safety Manager; Matt Arthurs, Philip Gardner, Kate Parrott, Mark King, Art Handling Team, Hayward Gallery; Alistair Ashe, Simeon Corless, Anna Nesbit, Consultant Audiovisual Technicians; Ali Brikci-Nigassa; Janet DeLuca; Pauline Dinis, Alan Pinkney, Security Team. At the Arts Council Collection, thanks are due to: Catherine Antoni, Acquisitions Coordinator; Steven Burridge, Collections Assistant; Shona Connechen, Loans Coordinator; Andy Craig, Senior Technician; Joshua Dowson, Stores Registrar; Ben Hudson, Technician; Natalie Rudd, Curator; Lizzie Simpson, Collection Coordinator, Longside.

John Akomfrah

(born 1957, Accra, Ghana;
lives and works London)

John Akomfrah is a filmmaker, artist, essayist and critic, known for his commitment to exploring black identity in Britain, and his interest in and exploration of archival and documentary film. He is the co-founder of the influential London-based media workshop Black Audio Film Collective (1982–98) and the production company Smoking Dogs Films. His documentary and dramatic works include *Handsworth Songs* (1987), *Seven Songs for Malcolm X* (1993), *Speak Like a Child* (1998), *The Nine Muses* (2010) and *The Stuart Hall Project* (2013). His many awards and honours include an OBE for services to film and honorary doctorates from the University of the Arts, London, Goldsmiths, University of London, and Portsmouth University.

Richard Hoggart, *The Uses Of Literacy*, 1957
Stuart Hall/Paddy Whannel, *The Popular Arts*, 1964
Louis Althusser, *Lenin And Philosophy And Other Essays*, 1971
Peter Wollen, 'The Two Avant Gardes', 1975, in Peter Wollen, *Readings and Writings: Semiotic Counter-Strategies*, 1983
Stuart Hall/Tony Jefferson, (eds.), *Resistance Through Rituals: Youth Subcultures in Post-War Britain*, 1976
Malcolm Le Grice, *Abstract Film And Beyond*, 1977
Judith Williamson, *Decoding Advertisements: Ideology and Meaning in Advertising*, 1978
David Curtis, *A History of Artists' Film and Video in Britain, 1897–2004*, 2006
Tanya Barson/David Campany/Lynda Morris/Mark Nash (eds.), *Making History: Art and Documentary in Britain from 1929 to Now*, 2006
Charles Esche/Tanya Leighton (eds.), *Art And The Moving Image: A Critical Reader*, 2008

Simon Fujiwara

(born 1982, London;
lives and works Berlin)

Simon Fujiwara grew up in Cornwall, near St Ives, with periods spent in Japan, Spain and Africa. He explores aspects of his own background in works that mix family history with fiction to produce installations, performances, texts and photographic works, often presenting multiple versions of himself. His works address his interest in culture, memory and alternative situations. He has exhibited in numerous large-scale exhibitions, including the Manchester International Festival, the Venice Biennale, the São Paulo Biennial and the Performa Festival, alongside group and solo shows at MoMA, New York, MOT Tokyo and Tate St Ives. In 2010 he was awarded both the Baloise Art Prize at Art Basel and the Cartier Award at Frieze Art Fair.

Joshua Simon, *Neo-Materialism*, 2013
Herman Melville, 'Bartleby, the Scrivener', in *The Piazza Tales*, 1856
Thomas Piketty, *Capital in the 21st Century*, 2013
Owen Jones, *Chavs: The Demonization of the Working Class*, 2012
Bruno Latour, *We Have Never Been Modern*, 1991
Joris-Karl Huysmans, *Against the Grain*, 1884

Roger Hiorns

(born 1975, Birmingham;
lives and works London)

Roger Hiorns' works encompass large-scale installations, individual sculptures and performances that mix everyday objects with unexpected interventions, from flames and naked figures, to aircraft engines and the brains of cattle. His celebrated installation *Seizure* (2008), for which he pumped 75,000 litres of copper sulphate solution into a council flat to create a grotto of deep-blue crystalline growths, was nominated for the 2009 Turner Prize and acquired by the Yorkshire Sculpture Park in 2011. His work has been exhibited in group exhibitions at the Art Institute of Chicago, Tate St Ives, Tate Modern, London, MoMA PS1, New York, and Walker Art Centre, Minneapolis, among many others, and in solo exhibitions including at Tate Britain, London, Camden Arts Centre, London, and Milton Keynes Gallery.

Poul Harremoes/David Gee/Malcolm MacGarvin/Andy Stirling (eds.), *The Precautionary Principle in the 20th Century: Late Lessons from Early Warnings*, 2002
China Miéville, *London's Overthrow*, 2012
Slavoj Žižek, *Violence*, 2009
Maxime Schwartz, *How the Cows Turned Mad*, 2003
The BSE Inquiry Report, 2000
John Berger, *Why Look at Animals*, 2009
Richard Benson, *The Farm*, 2005
John Onians, *Neuroarthistory: From Aristotle and Pliny to Baxandall and Zeki*, 2007
Mark Purdey, *Animal Pharm: One Man's Struggle to Discover the Truth About Mad Cow Disease and Variant CJD*, 2007
Rosalind Ridley/Harry Baker, *Fatal Protein: The Story of CJD, BSE and Other Prion Diseases*, 1998
Tadeusz Rósewicz, *Recycling*, 2001

Hannah Starkey

(born 1971, Belfast;
lives and works London)

Hannah Starkey was born in Northern Ireland and studied in Scotland, before settling in England. Her early photographic works were documentary in approach, but during the late 1990s she began to create images with a staged, cinematic character. The works often contain women in public or private spaces, whose static reflective poses, along with the images' particular lighting, create an enigmatic, melancholic tone. Alongside her commercial photographic practice, her works have been exhibited internationally in group and solo exhibitions at IMMA, Dublin, Saatchi Gallery, London, Museum der bildenden Kunst Leipzig, Schirn Kunsthalle, Frankfurt, Bard College, New York, Tate Liverpool, The Photographers' Gallery, London, the ICA, London, and the National Portrait Gallery, London.

Val Williams, *The Other Observers: Women Photographers in Britain, 1900 to the Present*, 1991
Erving Goffman, *Gender Advertising*, 1979
Jean Kilbourne (dir.), *Killing Us Softly: Advertising's Image of Women*, 1979/2010
Vance Packard, *The Hidden Persuaders*, 1957
Roland Barthes, *Mythologies*, 1957
Naomi Klein, *No Logo: Taking Aim at the Brand Bullies*, 1999
John Berger, *Ways of Seeing*, 1972

Richard Wentworth

(born 1947, Samoa;
lives and works London)

Richard Wentworth became one of the most celebrated artists associated with the re-emergence of British sculpture at the end of the 1970s. His exploration of the function and presence of objects in our everyday lives transformed traditional definitions of sculpture and photography, evidenced by his long-term project *Making Do and Getting By* (begun 1974) and his celebrated touring exhibition of artworks and objects, *Thinking Aloud* (1999). He has exhibited extensively internationally, including major solo exhibitions at the Whitechapel Gallery, London, the Venice Biennale, Tate Liverpool, Artangel, Bonner Kunstverein, Stedelijk Museum, Amsterdam, and Serpentine Gallery, London. In a long and influential academic career, Wentworth has taught at Goldsmiths College, London, the Ruskin School of Drawing and Fine Art, Oxford University, and the Royal College of Art, London.

Christopher Finch, *Image as Language: Aspects of British Art 1950–1968*, 1969
Claude Bertin, *La seconde guerre mondiale. Des plages normandes à Berlin*, 1962
Reginald Bell, *The Bull's Eye: A Tale of the London Target*, 1943
Manpower: The Story of Britain's Mobilisation for War, 1944
David Kynaston, *Austerity Britain 1945–51*, 2007
David Kynaston, *Family Britain 1951–57*, 2010

Bryan Appleyard, *The Pleasures of Peace: Art and Imagination in Post-War Britain*, 1989

Trevor May, *Agriculture and Rural Society in Britain 1846–1914*, 1973

Jane Wilson and Louise Wilson

(born 1967, Newcastle-upon-Tyne; live and work London)

Twins Jane and Louise Wilson began collaborating after studying fine art at separate universities, but exhibiting identical bodies of work for their BA degree shows. Early works comprised photographs and films of their performances, but with *Stasi City* (1997) their pieces began to explore wider political and cultural themes. More recent works, such as *Gamma* (1999) and *A Free and Anonymous Monument* (2003), are exhibited in the form of multi-screen installations and explore the legacy of modernism through specific architectural sites. The Wilson sisters have exhibited widely in group and solo exhibitions, including at the Kunsthalle Hamburg, Tate Modern, London, Kunst-Werke Berlin, Bergen Art Museum, Guggenheim Museum Bilbao and MoMA, New York. In 1999 they were shortlisted for the Turner Prize.

Beth Junor (ed.)/Katrina Howse (ill.), *Greenham Common Women's Peace Camp: A History of Non-Violent Resistance 1984–95*, 1995

A Guide For The Protection Of The Public In Peacetime, 2014

Peter Sloterdijk, *Terror From The Air*, 2009

Lawrence Alloway/Jacqueline Bass/David Robbins, *The Independent Group: Postwar Britain and the Aesthetics of Plenty*, 1990

Gilles Deleuze, *Cinema 1: The Movement*, 2005

Gilles Deleuze, *Cinema 2: The Time Image*, 2005

Giuliana Bruno, *Public Intimacy Architecture And The Visual Arts*, 2007

Clarice Lispector, *The Hour of the Star*, 1986

Félix Guattari, *Chaosmosis: An Ethico-aesthetic Paradigm*, 1995)

Paul Schimmel/Kristine Stiles (eds.), *Out of Actions: Between Performance and the Object, 1949–1979*, (exh. cat.), 1998

Sheila Dillon

(born Hoghton, Lancashire; lives and works London)

Journalist Sheila Dillon is best known as the presenter of BBC Radio 4's *The Food Programme*, on which she has worked for over 20 years. She began her career writing for the New York-based magazine *Food Monitor*. In the early 1980s and 1990s, having returned to the UK, she covered the emerging BSE/vCJD crisis with journalist Derek Cooper, and went on to report on the rise of GM foods and the growth of the organic movement. Her investigative journalism has garnered her awards including the Glaxo Science Prize, the Caroline Walker Award and several Glenfiddich Awards. In 2008 she was awarded an honorary doctorate by City University, London, for 'changing the way we think about food', and in 2010 she was awarded an Observer Food Monthly Outstanding Achievement Award.

Adrian Forty

(born 1948, Oxford; lives and works London)

Adrian Forty is Professor Emeritus of Architectural History at the Bartlett School of Architecture, University College London. He is the author of *Words and Buildings, a Vocabulary of Modern Architecture* (2004) and his latest book *Concrete and Culture, a Material History*, was published in 2012. He was the President of the European Architectural History Network from 2010 until 2014.

Daniel Fujiwara

(born 1979, Barcelona; lives and works London)

Daniel Fujiwara is Director of SImetrica, a research consultancy specialising in policy evaluation, and a member of the Centre for Economic Performance at the London School of Economics and Political Science. An economist, his research and work specialise in microeconomic theory, econometrics, non-market valuation, normative ethics and behavioural science as applied to policy evaluation. He has over 10 years of experience working in and advising governments and international organisations, including the governments of Australia, Ireland, Kenya, Poland, Tanzania and the UK, the World Bank, the United Nations, and the Organization for Economic Cooperation and Development (OECD). He also acts as referee for a number of academic journals.

Charlotte Higgins

(born 1972, Stoke-on-Trent; lives and works London)

Charlotte Higgins is the chief culture writer of the *Guardian* and a member of its editorial board. *This New Noise*, a book based on her nine-part series of essays on the BBC, is to be published by Guardian-Faber in 2015. Higgins began her career in journalism at *Vogue* magazine in 1995 and moved to the *Guardian* in 1997, where she has served as classical music editor and arts correspondent. A classicist by education, she is the author of three books on aspects of the ancient world. The most recent, *Under Another Sky: Journeys in Roman Britain* (2014), was shortlisted for the Samuel Johnson Prize for non-fiction, the Thwaites Wainwright Prize for nature writing, the Dolman Travel-Writing Prize and the Hessell-Tiltman History Prize. In 2010, she won the Classical Association Prize for her books and journalism.

Jackie Kay

(born 1961, Edinburgh; lives and works Newcastle-upon-Tyne)

Jackie Kay was born and brought up in Scotland. Her poetry collection *The Adoption Papers* (1991) won the Forward Prize, a Saltire Prize and a Scottish Arts Council Prize. *Fiere*, her most recent collection, was shortlisted for the Costa Award. Her novel *Trumpet* (1998) won the Guardian Fiction Award and was shortlisted for the IMPAC Award. *Red Dust Road* (2011) won the Scottish Book of the Year Award, and the London Book Award, and was shortlisted for the JR Ackerley Prize. She was awarded an MBE in 2006, and made a fellow of the Royal Society of Literature in 2002. Her children's book *Red Cherry Red* (2007) won the Clype Award and she also writes extensively for stage and television. She is Chancellor of the University of Salford and Professor of Creative Writing at Newcastle University.

David Alan Mellor

(born 1948, Leicester; lives and works Brighton)

David Alan Mellor has curated exhibitions and written widely about art, culture and photography, including, in the last five years: 'On Omaha Beach' and 'For the Protection of the Public in Wartime', in *Time: Conflict: Photography* (Tate Modern 2014); 'Second World War' in *Kenneth Clark, Looking for Culture* (Tate Britain 2014); 'Tony Ray Jones: English Comic Modernity on the Road to the Absurd', in *Only in England: Tony Ray Jones*, (The Science Museum, 2013); *The Bruce Lacey Experience/Sculpture, Paintings and Installations*, (Camden Art Centre, 2012, co-curated with Jeremy Deller); *Radical Bloomsbury* (Brighton Pavilion and Art Gallery, 2011); and 'And Oh! The Stench: Spain, the Blitz, Abjection and the Shelter Drawings' in *Henry Moore*, (Tate Britain, 2010).

Published on the occasion of the exhibition

History Is Now: 7 Artists Take On Britain
10 February—26 April 2015

Exhibition curated by Dr Cliff Lauson
Assistant Curator: Eimear Martin
Curatorial Assistants: Charlotte Baker,
Debra Lennard

Supported by:

The Henry Moore
Foundation

This exhibition has been made possible by
the provision of insurance through the
Government Indemnity Scheme. Hayward
Gallery would like to thank HM Government
for providing Government Indemnity and
the Department of Culture, Media and Sport
and Arts Council England for arranging
the indemnity.

Published by Hayward Publishing
Southbank Centre
Belvedere Road
London
SE1 8XX, UK
www.southbankcentre.co.uk

Art Publisher: Ben Fergusson
Staff Editor: Catherine Gaffney
Sales Officer: Alex Glen
Press & Marketing Coordinator: Diana Adell

Catalogue designed by Julia, julia.uk.com

This catalogue has been designed using
Granby, Johnston, and seven variations of
Times: Times, Times Eighteen, Times Europa,
Times New Roman, Times Ten and Life,
a typeface based on Times. This set is
completed by Times After, a cut designed
by Julia especially for this catalogue. These
seven variations pay homage to this British
classic and the way it has, throughout the
past century, responded to the changes
in the printing industry and the aesthetics
of society.

Printed in Spain by Grafos S.A.

The producers of *Kuru: The Science and the
Sorcery* (dir. Robert Bygott, 2010) wish to
acknowledge the contribution made by the
Fore people to the research on kuru and
to the making of the film, and note that the
film, and in particular the archival footage
used in it, was approved for public showing
by a representative group of Fore elders.

Distributed in North America, Central
America and South America by D.A.P. /
Distributed Art Publishers, Inc.
155 Sixth Avenue, 2nd Floor, New York,
NY 10013
tel: +212 627 1999
fax: +212 627 9484
www.artbook.com

Distributed in the UK and Europe,
byCornerhouse Publications
70 Oxford Street, Manchester M1 5NH
tel: +44 (0)161 200 1503
fax: +44 (0)161 200 1504
www.cornerhouse.org/books

All images copyright and courtesy the artist
unless otherwise stated

COPYRIGHT CREDITS

IMAGE CREDITS